RUSWARP & SLEIGHTS
THROUGH TIME
Alan Whitworth

AMBERLEY PUBLISHING

This book is dedicated to the residents of Sleights and Ruswarp, young and old, past and present, and especially John Coulson, of Sleights post office and the ladies at Botham's Bakery, Sleights, who see to nearly all my culinary needs. And of course, to my darling wife Alma, who brought me here.

First published 2011

Amberley Publishing
The Hill, Stroud
Gloucestershire, GL5 4EP

www.amberley-books.com

Copyright © Alan Whitworth, 2011

The right of Alan Whitworth to be identified as the Author of this work has been asserted in accordance with the Copyrights, Designs and Patents Act 1988.

ISBN 978 1 4456 0671 2

British Library Cataloguing in Publication Data.
A catalogue record for this book is available from the British Library.

Typeset in 9.5pt on 12pt Celeste.
Typesetting by Amberley Publishing.
Printed in the UK.

Introduction

Like two book ends, Ruswarp and Sleights each stand at the termination of The Carrs, a highway that runs alongside the River Esk for much of its length. The Carrs takes its title from the topography of the landscape and means 'marshy ground', and indeed, through the centuries up to the present day, in winter months it is often flooded and impassable.

Today, most of the course of the River Esk lies within the North Yorkshire Moors National Park, an outstanding area of countryside. During the nineteenth century, this part of Yorkshire was mostly wild and inhospitable – high moorland intersected by deep, wooded valleys, with small hamlets scattered here and there. Even nowadays those who know and have visited this district realise only too well that it is surrounded on the landward side by hills in every direction, and that all traffic to and from the interior has to be taken over these natural impediments, which in winter are made even more hazardous by the weather. In olden times, these natural barriers were, no doubt, even more of an obstacle, due to the type of vehicles and the state of the highways themselves.

Both Ruswarp and Sleights have ancient origins, though Sleights appears older and witnessed settlement in prehistoric times, as evidenced in archaeological excavations that have revealed hut circles, burial mounds and standing stones. Yet Ruswarp is not without history and was colonised before the Norman Conquest, when records show that there was an established mill on the river bank in the ownership of the monks of Whitby Abbey.

Ruswarp is now practically a suburb of Whitby, and at the beginning of the twentieth century was described as 'by way of becoming a fashionable resort of holiday-makers'. Today, in part this is true. 'Its situation on the banks of the Esk is delightfully picturesque'. Because of this, in recent times particularly, numerous holiday cottages and B&B establishments have sprung up. Amenities for visitors include boating, a children's all-weather adventure playground, a paintball course, a miniature steam railway, a general store, a zoo and a fine public house. Before that, the water-powered corn mill was the focal point of an industrial period, and previously it had an important salmon fishing industry.

Likewise, Sleights is a popular destination for holidaymakers and visitors with its own unique attractions. It also has a history of industry contributing to its growth and prosperity in times past – alum and ironstone mining, leather tanning, brickyard and brick manufactory – which have now gone, and the scars they left behind are practically invisible. However, place-names and clues still exist and for the observant and interested, the sites of these industries can be traced.

As a long-time resident of Sleights, once an ecclesiastical parish of some size, technically I live in the hamlet of Briggswath, one of a number of individual hamlets within its boundaries. Indeed, Sleights as a parish does not exist; its correct title is Ugglebarnby-cum-Eskdaleside, reflecting the extent of its boundaries. However, many of these hamlets became separate parishes with separate identities and in modern times have become even more diversified. Some of the new trappings have made an obvious impact, other changes have been more subtle, and it is only on reflection with hindsight that we can observe the gains and losses.

At Briggswath for instance, when I arrived here thirty years ago there were so many more trees than today, and the trees were filled with rookeries that had been present for some considerable time. A survey of rookeries was organised by the British Trust for Ornithology in 1945. An area 670 square miles in the eastern half of the North Riding was covered. Sleights alone produced four rookeries with over 400 nests. There were two rookeries of 211 and 40 nests respectively on the Woodlands Estate; one of 97 nests on Coach Bank and one of 57 nests at Briggswath. The Sleights rookeries totalled 405 nests and at that time another new rookery was being started in Sleights churchyard, and there were a great many nests at Sleights Hall. All of them have now gone, as are many of the trees, and looking back I cannot remember just when the raucous cries of these birds fell silent, but it must have been at least fifteen years ago. Such is the trick that time plays on the memory.

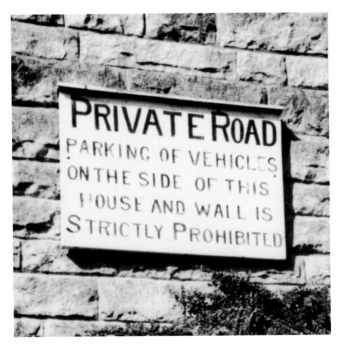

A Sleights resident with a sense of humour and little idea of grammar; indeed, it would be very difficult for anyone to park a car on the side of any house in Sleights, or the garden wall for that matter!

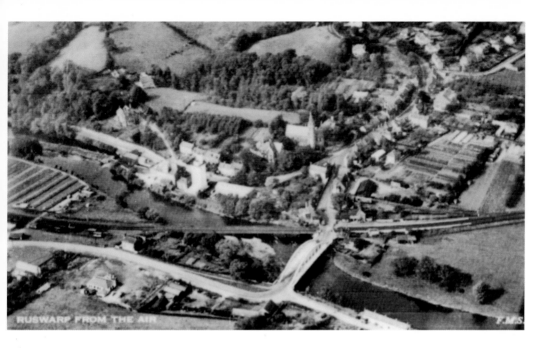

Ruswarp from the Air

From the air you can see the River Esk, and how both the road and rail bridges that span it interact. The church is evident, as is the large Georgian house on the corner of The Carrs, which was demolished to make way for the open space and village green. The mill can be seen, and the cottages at the very bottom of the photograph stand on what was a staithe. Indeed, Ruswarp was at one period a busy port, the River Esk being tidal up to the mill.

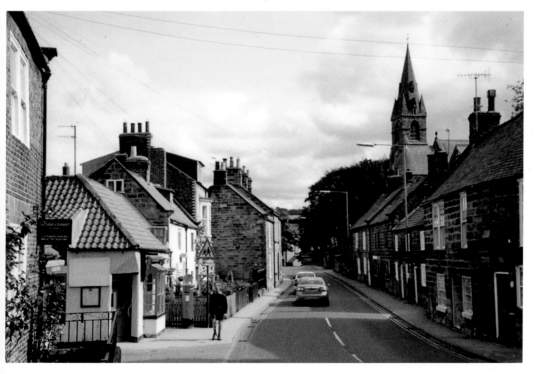

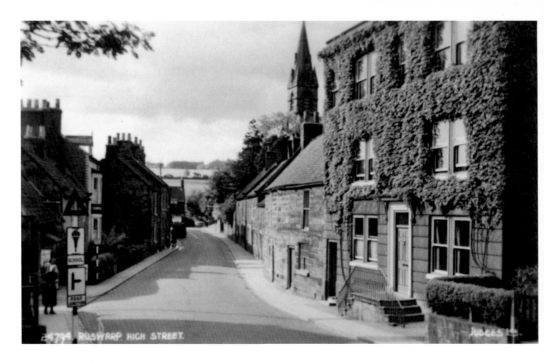

Ruswarp High Street

The High Street at Ruswarp at this point has changed very little since the eighteenth century – which most of the buildings seen here date from – except that there is no ivy on the Georgian building. The church of St Bartholomew, with its distinctive spire, is a nineteenth-century edifice opened on 30 September 1869. Sadly, in 2011 the village post office closed after over a century of service. Nevertheless, the village still boasts a general store and a butcher's, which ironically now sells the local newspaper.

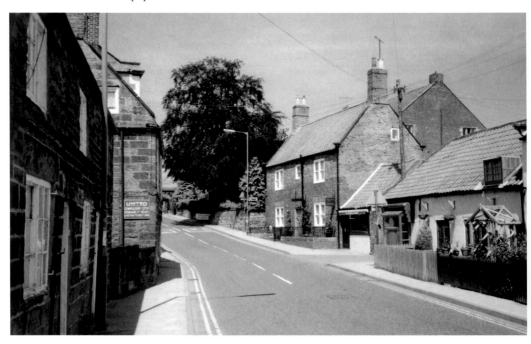

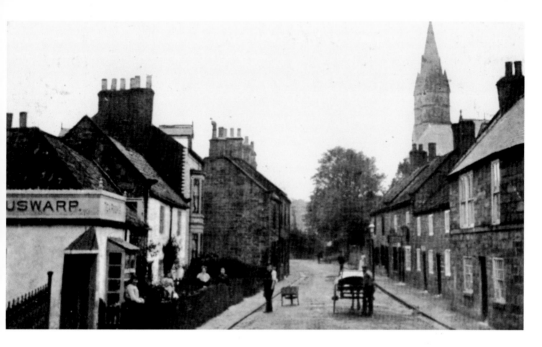

What's In a Name?

At what point this district was populated is unknown, but the Domesday Book mentions a mill at Ruswarp, suggesting that the community was already well-established. At that time Ruswarp was owned by William de Percy. Ruswarp was first known as *Risewarp* (in 1377 *Ryswarp*). Canon Atkinson derives the name from the word 'rise', 'brushed wood' and 'scarp', meaning a dam. However, 'warp' also translates as 'a bank of mud deposited by a river'; a look at the Esk at low tide here demonstrates the aptness of this description.

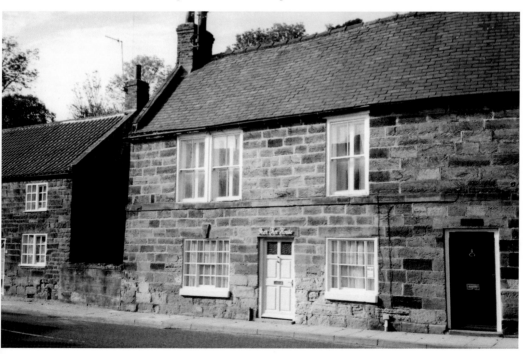

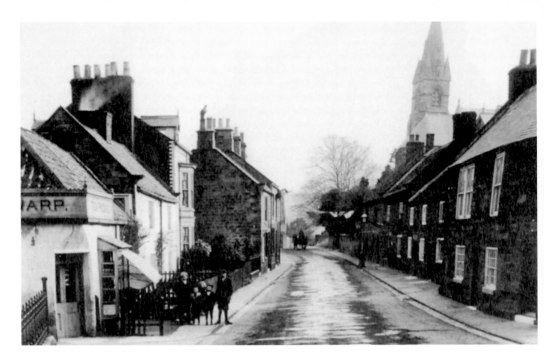

Ruswarp High Street

Ruswarp itself at one time covered a considerable area, and stretched from as far as Sneaton Castle down into Whitby town, where a boundary marker high in the wall beside the Little Angel Inn in Flowergate marks its junction with Whitby, and another boundary marker behind Broomfield Terrace, set low in a wall, marks its junction here with the town. The poor house of Ruswarp stood in Stakesby Vale, and is today marked by a modern bungalow on Stakesby Road near to the ornate gates that were the entrance to Stakesby House.

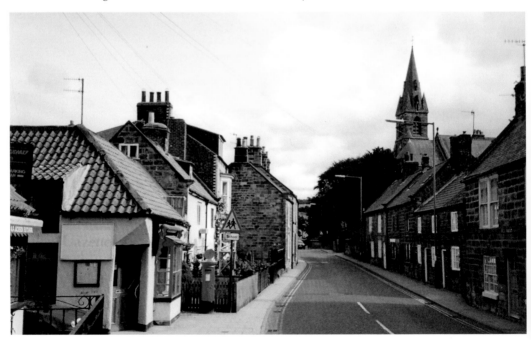

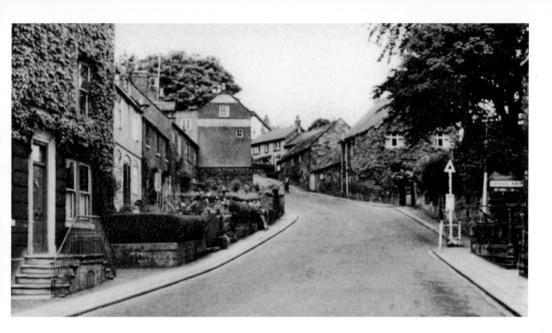

Ruswarp Bank

Little has changed in Ruswarp over the centuries, as demonstrated by these two photographs: the upper one taken *c.* 1955 and the lower in June 2011. In 1811 there were 104 males and 118 females living in the village, yet by 1814 the Ruswarp Rent Roll totalled more than £11,000 a year; Whitby's Rent Roll totalled £16,000. Ruswarp's was this high because the ship-owners and merchants of Whitby realised that all they had to do was move into Bagdale, Flowergate, Cliff Street, or St Hilda's Terrace, and they were in Ruswarp, where it was cheaper to live.

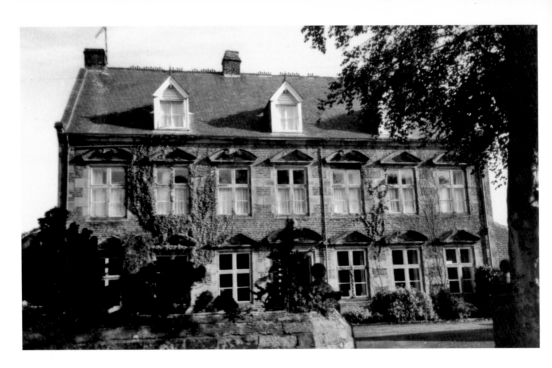

Ruswarp Hall

Near the bottom of Ruswarp Bank stands Ruswarp Hall, built in the Jacobean style of architecture at the expense of Nicholas Bushell, a prosperous ship-owner and merchant of Whitby. He resided at Bagdale Hall in Whitby and used the property as a summer retreat from the noxious smells of the town. Around 1634, Captain Browne Bushell was living at the hall. Following the English Civil War he was beheaded on Tower Hill, London, accused of being a traitor to his country.

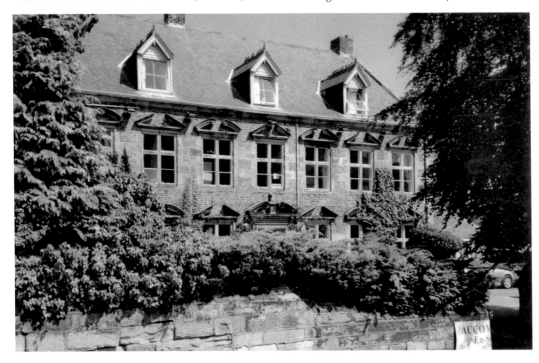

Hidden Ruswarp

Down the side of Ruswarp Hall runs an ancient footpath that leads toward the river, passing on its way a number of smart properties and the old chapel that have their backs and access via the stream bed of the water course that runs under the road and comes out between the butcher's and the old post office before running down to the Esk. Topographically, the lowland areas of Ruswarp were formed from contact with the river, which overflowed regularly creating marshy ground. The Esk below Ruswarp no longer follows its old course. In the eighteenth century, plans were proposed to create a canal to link with Pickering and the Esk from Whitby to Ruswarp. An undated Whitby map of around 1811 carries the legend, 'Granary, was formerly the Mill at Ruswarp belonging to Mrs. Cholmley. Line of Canal made about sixty years ago by Nathaniel Cholmley, Esq, to Facilitate the Communications between the Harbour and Ruswarp Mill.' The portion that was cut off remained as a small lake, and became a favourite haunt of eel-fishers, and skaters in winter.

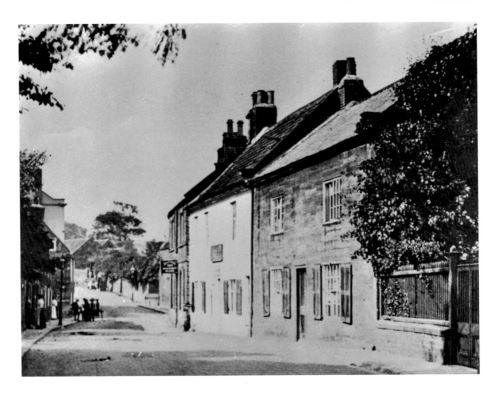

Ruswarp High Street

A view of the middle of Ruswarp High Street, looking towards Ruswarp Hall and the steep hill known as Ruswarp Bank. On the left are the walls of the churchyard. On the right, one of the buildings was at one period an inn. Opposite stood a public house, known today as Pear Tree Cottage. Today only the Bridge Inn survives. This is one of the oldest parts of Ruswarp. On 26 January 1903 Henry Nethercolt, a Crimean veteran, died at Ruswarp.

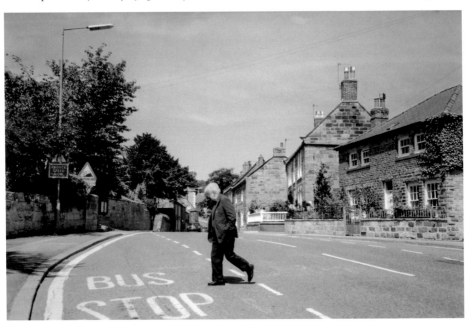

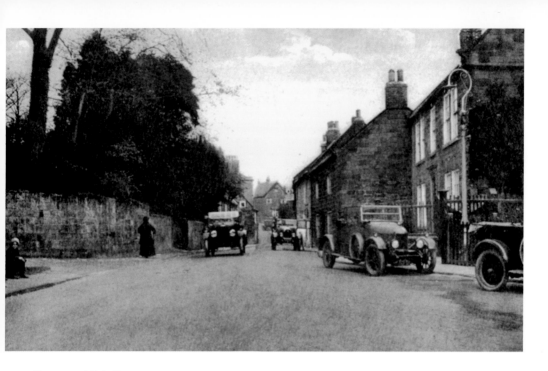

Ruswarp High Street

In the upper photograph, taken around 1930–32, there appear to be just as many vehicles as there are today. This is the lower end of Ruswarp High Street, where halfway along the grocer's stands in the same place today as yesterday. We can see someone alighting no doubt to make a purchase or two. There are so many parking restrictions and the road is so narrow that it is impossible to stop at this point – and those that do – delivery wagons for instance – can cause tremendous hold-ups.

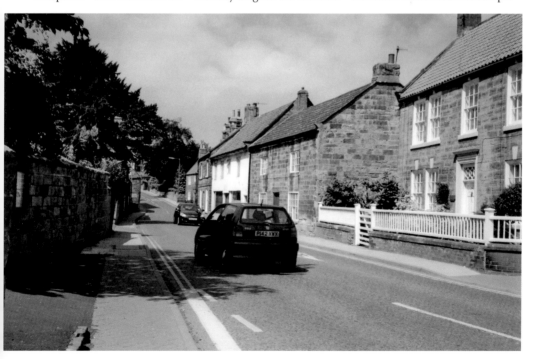

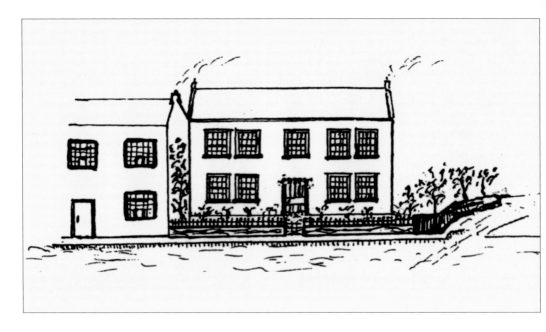

The Revd Thompson's House

In the nineteenth century, the influential minister of the Whitby Presbyterian Church, Revd Peter Thompson (1778–1806), lived in Ruswarp. He came to Whitby on 22 December 1799 aged twenty-three years. The Revd Thompson was well-respected for his sermons, many of which were published. He first lived in the town but moved to Ruswarp on account of his health, and occupied this house, which was once lived in by the Hall family. He remained at Ruswarp for a little over four years before moving to Leeds. The drawing was discovered in the nineteenth-century *Chapel Minute Book*.

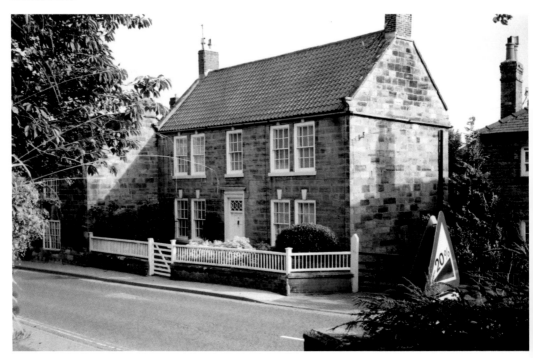

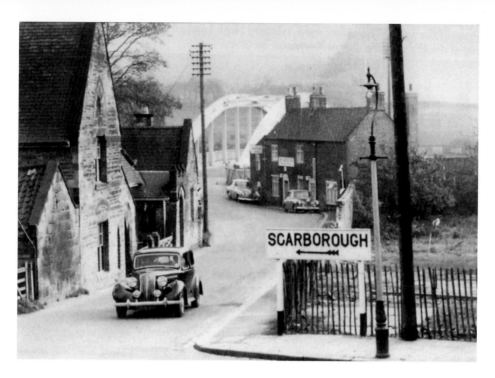

Ruswarp Village Centre

If you turn around from the viewpoint on the previous page you are looking toward the River Esk. The Church of England schoolhouse on the left, complete with a teacher's accommodation, was opened in 1878. Built at a cost of £700 by public subscription, it is still in use today. The pub is the Bridge Inn and the road crosses over the metal girder bridge and leads to Scarborough. On the large grass area stood a magnificent Georgian house and garden, not long demolished when the top photograph was taken in the 1950s.

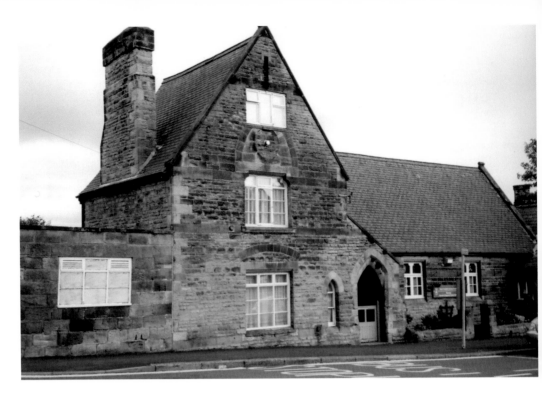

Ruswarp School and Bridge Inn

When first opened, the school was designed to accommodate 100 pupils who were strictly segregated as the two entrances demonstrate – Boys and Girls. However, school records show that only about fifty pupils attended at any one time. The Bridge Inn is now the only public house in the village to remain open. One other inn was called The Unicorn, another The Pear Tree. A careful examination of the exterior of the Bridge Inn shows that it has grown over the years and taken in neighbouring cottages; its entrance is also below street level.

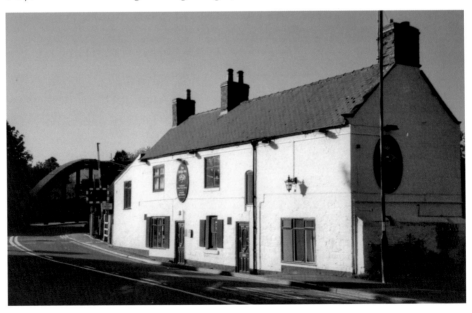

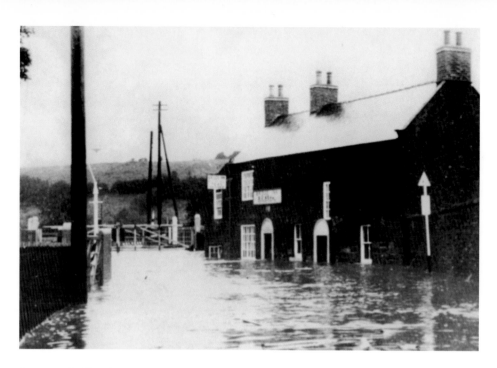

Ruswarp in Flood, 1930

The Esk is prone to flooding hereabouts, not solely in winter, but also in summer. The most spectacular flood has to be that which occurred on 23 July 1930. On this day, the waters reached a height of 5′ 2″ in the tap room of the Bridge Inn. Villagers in their homes had to be rescued by local men using the pleasure boats. In another flood a few years later, the lifeboat was brought overland by road, hauled by hand from Whitby, to rescue those trapped in their cottages and this is shown on the next page.

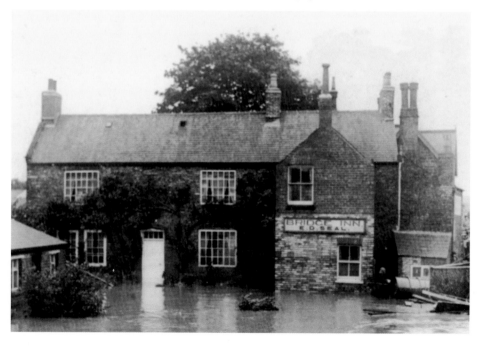

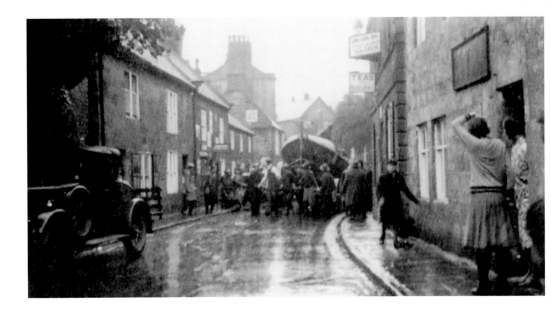

Ruswarp Floods

The flooding of the Esk Valley in July 1930 was by far the worst since 1828, although there were devastating floods in July 1840 and September 1931. It was during this flooding that a dramatic incident took place when the smallest of the town's lifeboats was taken to Ruswarp to rescue two trapped women. The *Jacob and Rachel Valentine*, a rowing lifeboat, was pulled by horses from Whitby to the aid of Mrs Hanson, aged ninety, and Mrs Robinson. The lifeboat was in the charge of Coxswain Joseph Tomlinson.

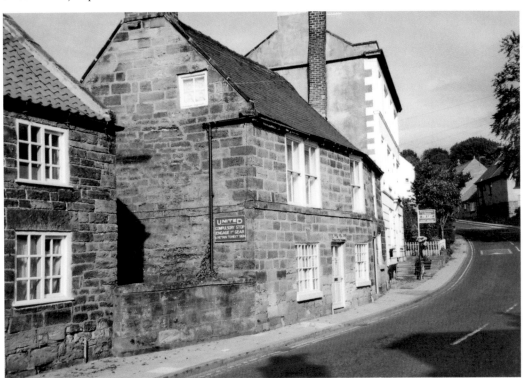

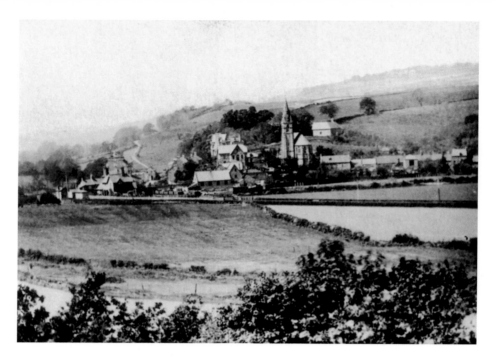

Ruswarp from Larpool Lane

A view across the River Esk toward Ruswarp village from above Larpool Lane: today this view is not possible as a number of trees have grown up, obscuring the view. The railway is self-evident as a straight line across the middle of the photograph, and at the bottom the back road runs up to Larpool Hall and today continues through an estate of modern housing to join the main Scarborough Road. The viewpoint I suspect for this was on top of Shawn Rigg, which today houses a static caravan park.

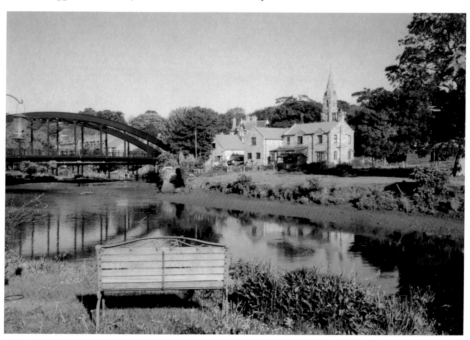

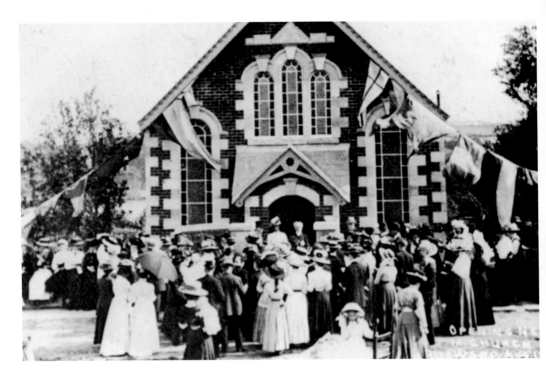

The Primitive Methodist Church

This is an interesting photograph, taken on 17 August 1910 at the opening of the new Primitive Methodist church. Looking at the photograph and knowing the location of the chapel, I cannot yet make out how the congregation would get to a service. Today a private house, a footpath alongside Ruswarp Hall is the only 'dry' route and there is only the path width, as a huge hedge enclosing the rear garden to the hall prevents any possibility of gaining a similar viewpoint, which appears to be taken on an open field.

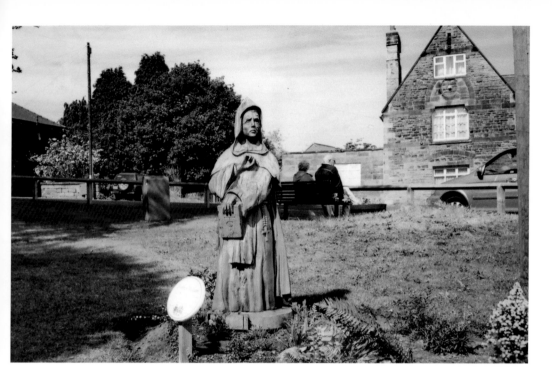

Ruswarp in Bloom

Ruswarp is a village valued by residents who have done much to make it attractive. Indeed, only this year their care has been rewarded by a gift from Whitby in Bloom – 'Brother William', carved in oak by Tommy Craggs, which marks Ruswarp being named a RHS Britain in Bloom National Finalist in 2011. Brother William was one of two monks from Whitby Abbey who worked at the mill. Unfortunately, they were too fond of indulging in a mug of ale, and eventually they were recalled to the monastery.

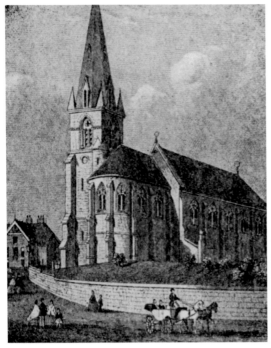

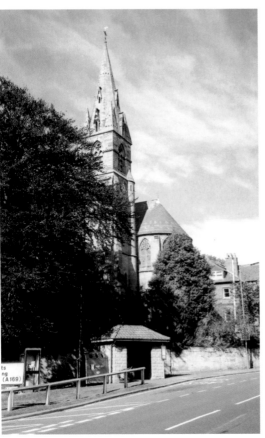

The Church of St Bartholomew

At the centre of Ruswarp stands the church of St Bartholomew. The Archbishop of York laid the foundation stone of the church on 5 August 1868, and the building opened for worship on 30 September 1869. It is situated on a piece of ground raised above the road, the slope of which has rendered it necessary to give a considerable elevation to the west end that terminates in an apse. The difficulties of the site have, however, been entirely overcome by the architect, and the structure, belonging to what is described as the Early Decorated period, is imposing. The building consists of a nave, chancel, organ chapel, children's aisle, vestry under tower, and south-west porch. The intention had evidently been that the interior should receive colour decoration, and this was carried out so far as regards the roof of the chancel. The chancel windows are of stained glass. Some of the woodwork is by Thompson of Kilburn, the famous 'Mouseman'. An interesting feature is the small metal crucifix above the war memorial. This was found on the battlefield of Ypres, in Flanders, during First World War, and was picked up by a soldier from the village and given to the church as a curiosity on his return. The hole through the middle was caused by a bullet.

Ruswarp Vicarage

Adjacent to the church is the vicarage, built in 1870. The first vicar was Revd James Dingle. He remained until 1901, and held church services at Ruswarp Hall in the early 1860s. An interesting journal survives, written by Henry Benson, treasurer of the church building committee. In the course of his collection he made private notes about the residents: 'Mr & Mrs. Jackson gave 2s – They never come to church except to bring the children to be baptised. They now have seven'. 'Mr. Comer, a publican, never comes to church'.

Turnerdale Hall and Red House

Turnerdale Hall, was built in the nineteenth century for the industrialist George Peters, and later became the home of Mr. Henry A. Herton Rastall JP, whose son, Robert H. Rastall, lived at the Red House (below). At one period, large lettering on the roof proclaimed that it was a café. In March 1946, Robert Rastall was honoured by the Geological Society of London with the gift of the Lydell Medal in recognition of his work and research in the field of geology. He was at that time editor of the *Geological Magazine* and a noted author on the subject having written numerous original papers on the geology of Cambridgeshire, Cumberland and Yorkshire, as well as ore deposits, along with several books. He was educated at Christ's College, Cambridge, and was a Fellow of that college, where he was for some years a lecturer in Economic Geology, specialising in tin deposits. He then travelled extensively in South Africa and Malaya on geological work. During World War I the War Office employed Robert Rastall, though his role there is unclear. Red House later became a residential nursing home, which was sold off in 2004 and turned into apartments.

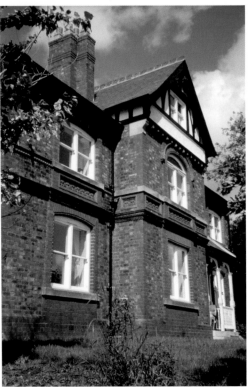

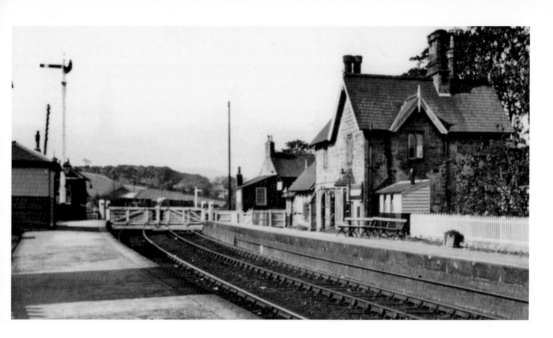

Ruswarp Railway Station

Ruswarp railway station was erected in 1850 to a design by George T. Andrews, architect for the Yorkshire & North Midland Railway. He was a friend of George Hudson and designed many of the bridges and stations for Hudson's great railway empire. It is constructed in the 'Tudor style', and the stationhouse is now a private residence with the platform still in use. Notice the level crossing gates, now replaced by a modern rising barrier system and the absence of one of the platforms.

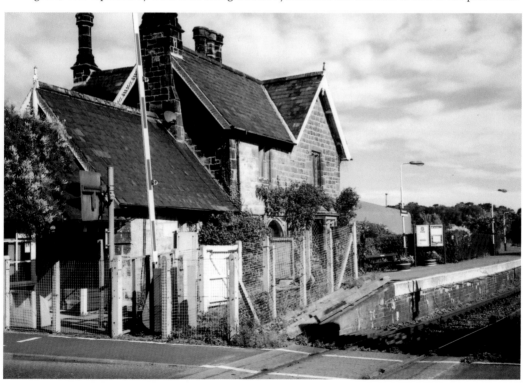

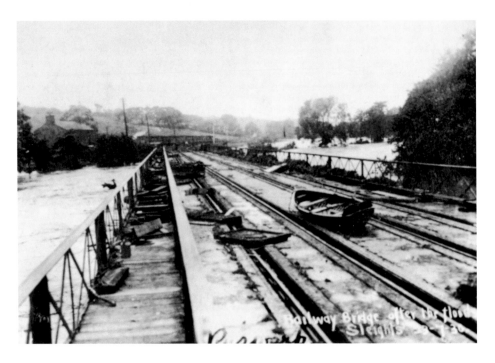

Ruswarp Railway Bridge

The arrival of the railway at Whitby, along with stations at Ruswarp, Sleights, and other stops along its length, marked the start of modern times and brought with it incredible change to the district. Built by George Stephenson, it ran from Whitby to Pickering and was opened on Thursday 26 May 1835. Above is a scene showing the debris scattered over the railway line following the flooding of July 1930. This includes the Ruswarp pleasure row boats which were torn from their moorings and carried downstream.

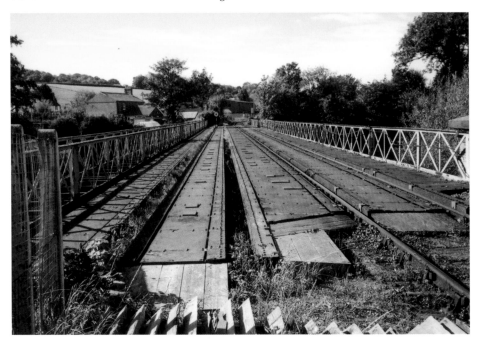

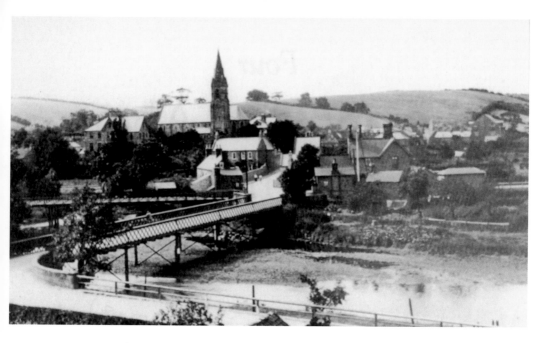

Ruswarp Railway Bridge

The first and longest bridge was erected at Ruswarp. It was built of Baltic Pine and carried the track across the river in a diagonal direction. It was 312 feet in length, divided into five spans of 62 feet each, and the framework of the total length was supported upon four rows of wooden piles, placed obliquely so as to offer the least resistance to the natural tidal currents. The pilings were firmly strapped together by iron bands. In time, of course, this bridge was replaced by the present iron girder construction.

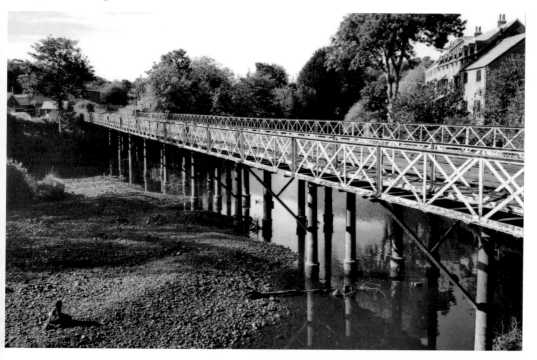

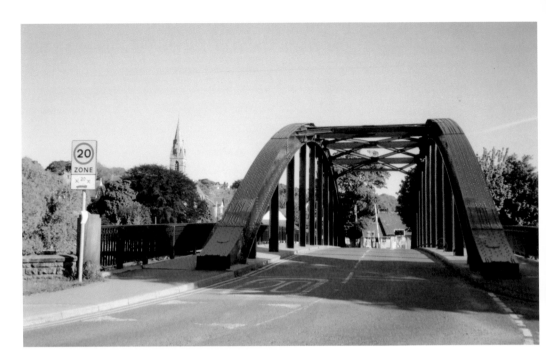

Ruswarp Road Bridge

The original road bridge at Ruswarp was replaced after flood damage and the now-curved iron girder bridge replaced that in 1933. Ten years ago it was blue; today however, in sympathy with its rural surroundings no doubt, whoever decides these things has had the colour changed to green so it blends in with the countryside. An interesting feature of the new bridge can be seen in the stone wall leading up to it, where in the Second World War the bridge name was carefully chiselled off as instructed in order to make life difficult for any invading Germans.

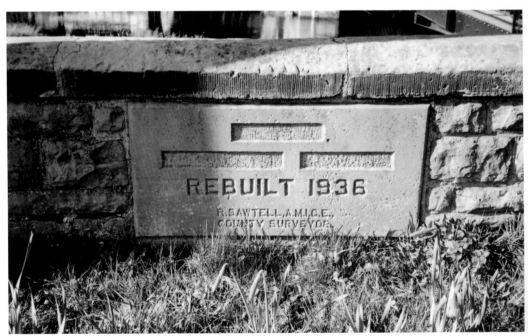

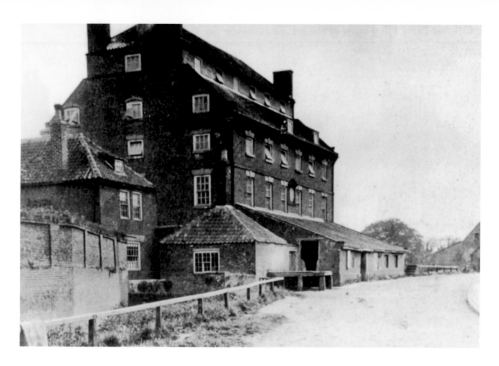

Ruswarp's Water-Powered Corn Mill

Ruswarp Mill was mentioned in the Domesday Book, and belonged to the monks of Whitby Abbey. A water-powered corn mill, it was later rebuilt and became a Bolting Mill carrying the inscription, 'Erected at the Expense of Nathaniel Cholmley by Philip Williams, Engineer, 1752' (see page 33). In 1990, the mill and site was converted into luxury apartments and a small housing complex. On 11 January 1891, James Bell drowned whilst skating on Ruswarp Dam. That same year G. Constable and W. T. Cummings drowned in Ruswarp Dam on 19 July.

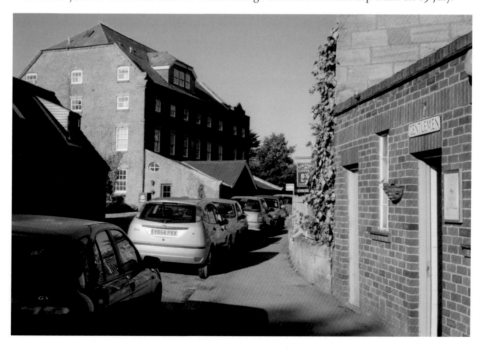

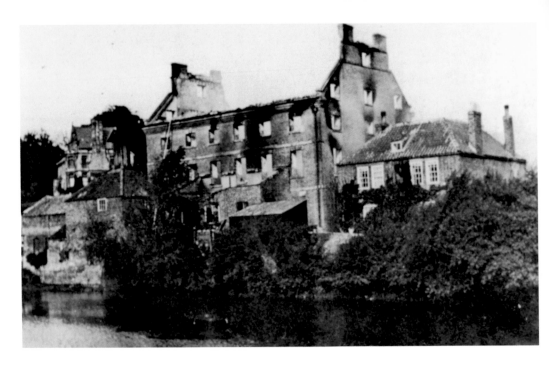

Ruswarp Mill

There have been three mills here. The site of the earliest mill stood upstream to the present mill. When the two mills existed together, the older mill came to be known as Ruswarp Country. It was still standing in 1682 when a mortgage document states, '...all those three water corne mills called Riswarpe Mill and all the salmon fishing from the said dam unto the mouth of the River Esk... late in the tenure or occupation of John Longstaffe...' Relics of this early mill were demolished in the 1980s.

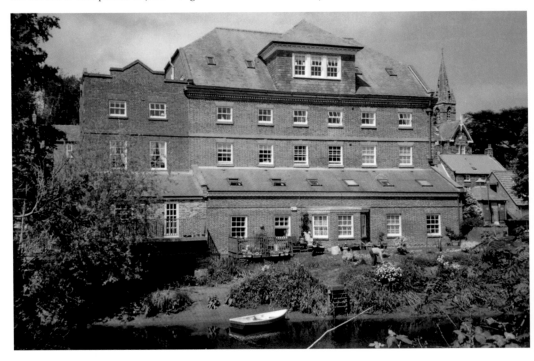

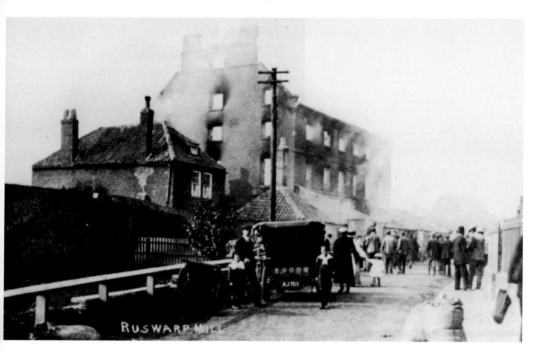

Ruswarp Mill Fire

A number of postcard views exist of the great fire at Ruswarp Mill, which was destroyed on 25 September 1911. This Ross card shows the interest created as the ruins still smoke the following day. The miller then was Henry Bryant Bell. Interestingly, the photograph below, which must have been taken at the same time, does not show the vehicle, but bizarrely shows a stray sheep in the bottom left corner appearing on both photographs! Rebuilt it ended life as a provender mill producing animal feed, eventually ceasing production in 1962.

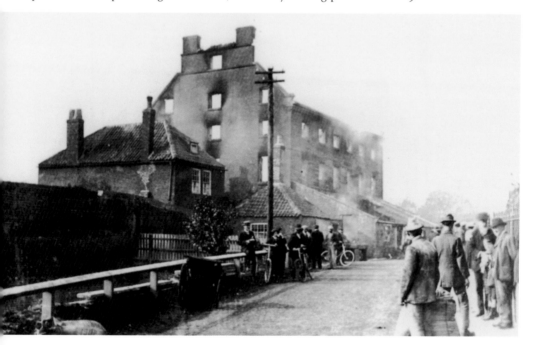

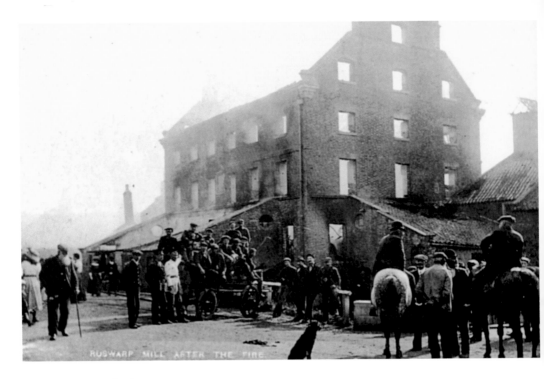

Ruswarp Mill Fire

This is an unusual and rarely seen postcard of the great fire, by E. Hall of Whitby. It shows one of the fire engines, scarcely visible under the crowd of men, some of which were no doubt the firemen. Notice the old gentleman with white beard to the left ambling along – no sense of urgency here! The mill today from the same viewpoint, now converted to apartments, has an extension, which was added to the gable end after the fire. The arch on the road level (below) covers the mill race and houses the waterwheel.

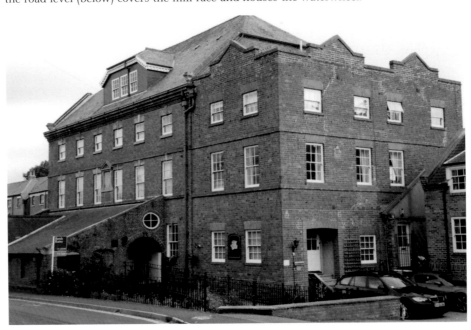

Ruswarp Mill

A tablet on the mill, above, tells how 'These Mills were erected at the expense of Nathaniel Cholmley Esq. by Philip Williams, Engineer, 1752 *Aureum Dei Donum Frumentum Molimus*' (We grind the corn, the golden gift of God). Below is the miller Henry Bell, *c.* 1890, who is checking the mill race for debris. We have mentioned a number of fatalities related to the mill, and another later incident was that of Mr Christopher Lythe, aged fifty-three, who was found dead in Ruswarp Dam on 26 January 1903. In 1910 the mill was owned by Sir Francis Ley, of Lealholm.

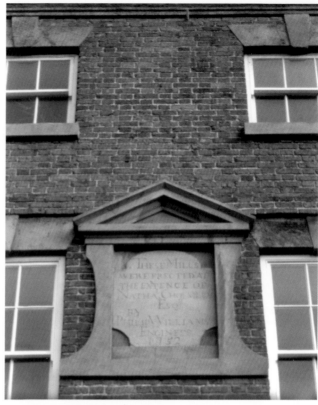

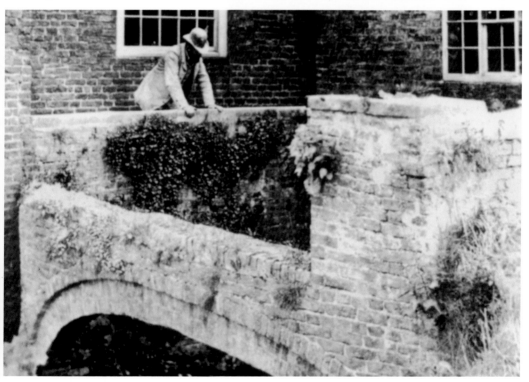

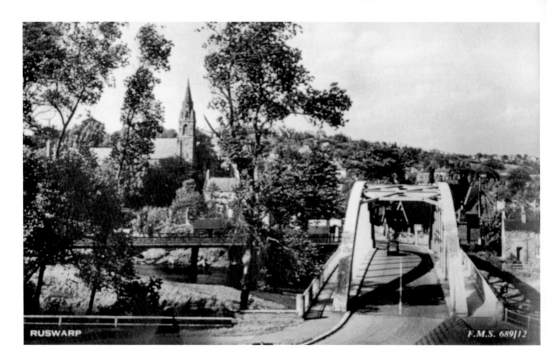

RUSWARP

F.M.S. 689/12

Ruswarp from Across the River

Hardly any change has occurred between the two photographs in fifty years. Only subtle differences can be observed, such as the top photograph showing the Georgian house (below church) that dominated the road junction, and which is missing on the bottom photograph – and the trees have grown, almost blotting out the church in the bottom photograph. On 26 August 1871 Ruswarp Fair was abolished. This took place on 6 July each year, or the following Monday if that date fell on Saturday or Sunday. When it was established is unknown and it had no Charter.

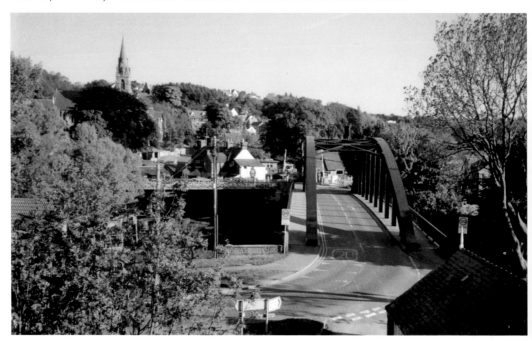

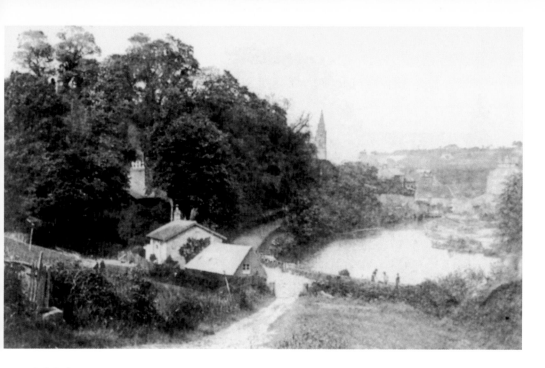

Esk Leisure

The schoolhouse mentioned on the previous page can clearly be seen in the views from this farm track, but today the track lies under tarmac and the school is obscured in the modern view by the building, which has now been enlarged until it dwarfs the old school. Ruswarp is still a favourite spot for holidaymakers, with its miniature railway, rowing boats, children's zoo and fun house from whose car park this photograph was taken. A little fact: in 1826 the then oldest resident, Dorothy Burley died aged 100 years and two months.

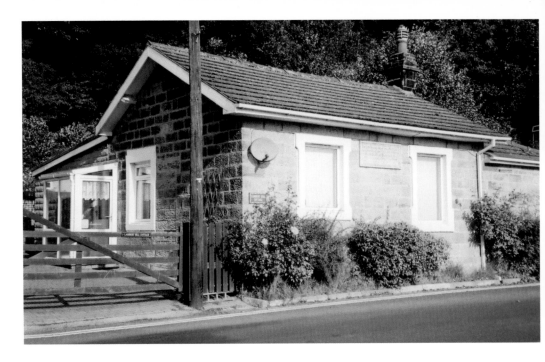

Ruswarp Old School
Opened in 1848, 'This School was erected for the benefit of the Poor of Ruswarp by John Elgin, of Prospect Hill as the bequest of his late Son William Elgin, AD 1848.' Now converted to a house and slightly but tastefully enlarged, for many years the inscription was covered over with a board, but the present owner with a sense of history removed the wood board so all could enjoy the history of the building. This small stone edifice stands opposite the landing stage of the pleasure boats.

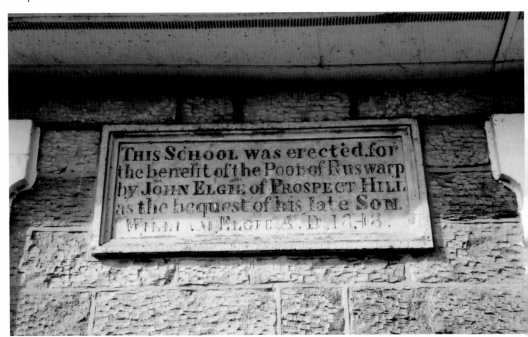

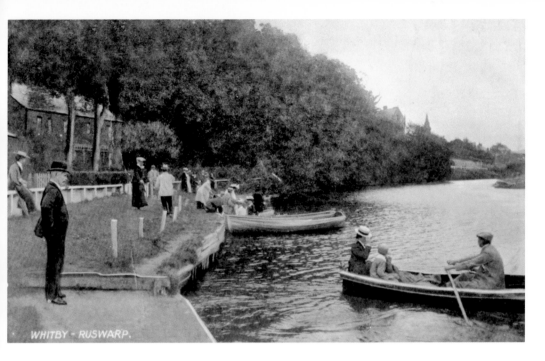

WHITBY - RUSWARP.

Boating on the Esk

In 1793, a canal between Ruswarp and Pickering was proposed for the conveyance of lime, grain, timber, *et cetera*. A survey was carried out by William Crossley, engineer, under the direction of a committee, and a plan and estimate, with observations, was published in 1794 by Francis Gibson, chairman of the committee. The depth was to be 4½ feet; width at top 30 feet; at bottom 18 feet; each lock 24 yards long, 4 feet deep and 4 feet wide. In the event the canal was never constructed but a dam was built across the Esk above the mill.

Ruswarp Boats

Apart from the lack of a decent landing place, these two images could be the same photograph, but some forty or fifty years separate the two in time. The original dam was described as a 'fish-weir', and was made of brushwood with wooden piles driven in first. There were three rows of piles across the river. These were 'weddered up', and made a pretty solid structure that had to be renewed every year. Undoubtedly this form of construction had been employed since medieval times.

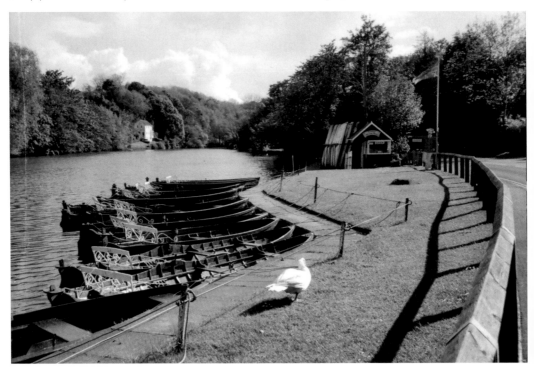

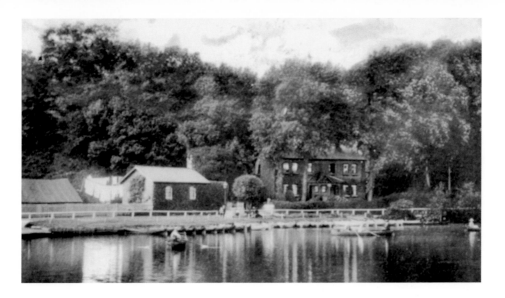

Ruswarp Pleasure Boats

The famous artist George du Maurier and his equally famous children, Daphne and Gerald, often enjoyed picnics and rowing at Ruswarp – and it featured in this *Punch* cartoon of 1882 where it was common practice to haul the boats up the dam. Below the weir is tidal. In the upper photograph the ivy-clad building was the original schoolhouse of the village, opened in 1848 'for the benefit of the poor', but notice here that it is covered in ivy and where the washing is hanging is now an extension.

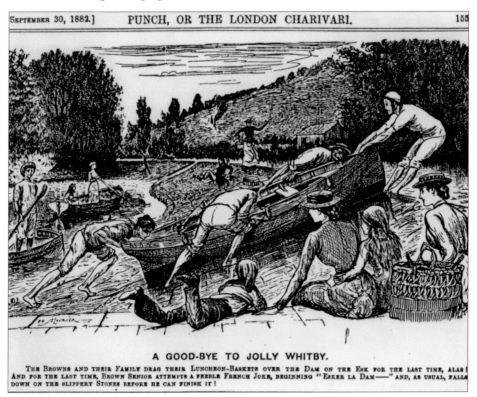

SEPTEMBER 30, 1882.] PUNCH, OR THE LONDON CHARIVARI. 155

A GOOD-BYE TO JOLLY WHITBY.

THE BROWNS AND THEIR FAMILY DRAG THEIR LUNCHEON-BASKETS OVER THE DAM ON THE ESK FOR THE LAST TIME, ALAS! AND FOR THE LAST TIME, BROWN SENIOR ATTEMPTS A FEEBLE FRENCH JOKE, BEGINNING "ESKER LA DAM——" AND, AS USUAL, FALLS DOWN ON THE SLIPPERY STONES BEFORE HE CAN FINISH IT !

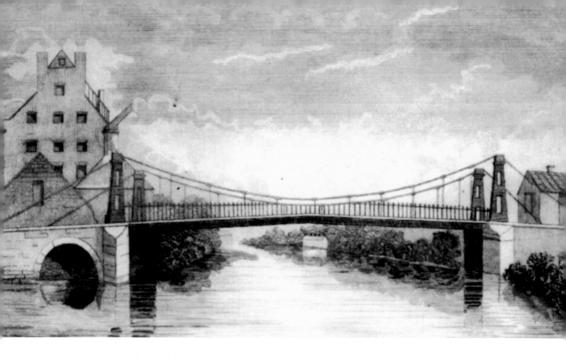

Ruswarp Suspension Bridge

Around 1820, a Colonel James Wilson bought estates in Sneaton and had the architect William Hurst rebuild Sneaton Castle. He also designed a church and school building for the village of Sneaton, and in order for Colonel Wilson to travel easily between Sneaton and his country seat, he had this suspension bridge built across the river, which was later destroyed by flooding in July 1828. This bridge was constructed by a Captain Samuel Brown RN in 1825 and was one of the earliest examples of a suspension bridge in England.

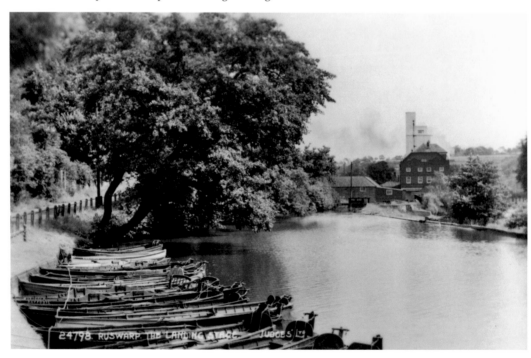

24798. RUSWARP THE LANDING STAGE. JUDGES' LT.

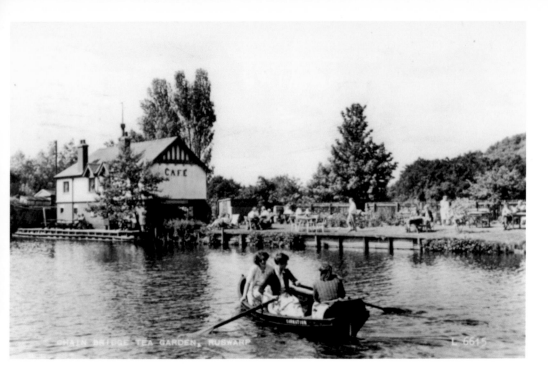

Chainbridge Tea Gardens

Apart from the famous artist George du Maurier, the novelist Storm Jameson came to live at Ruswarp in 1924 and her son went to school in Whitby. No doubt they, too, enjoyed the delights of the river. The upper photograph shows the boats passing the Chainbridge Tea Gardens (page 25) sometime in the 1950s. A favourite spot until the late 1960s was the Chainbridge Café on the banks of the River Esk at Ruswarp. It took its name from one of the suspension bridges.

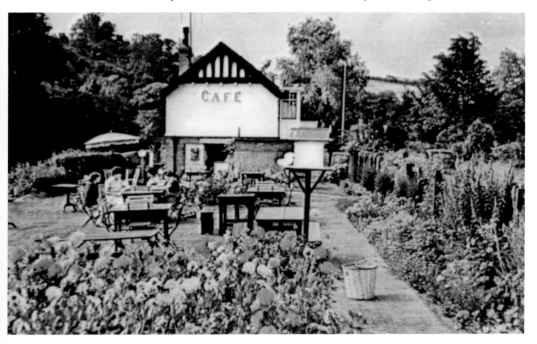

Chainbridge Miniature Railway

These modern photographs show the house on the previous page as a café, altered with a new roof line and no longer operating as a tea room. Sometime in the 1960s the owner set up a small caravan site on the land, some years later this closed and another owner established the narrow 12-inch-gauge miniature railway and built a small number of chalets to replace the caravans. In 2011 the new owners took over and completely refurbished the railway and chalets, and in the summer months it is an ideal spot to stay.

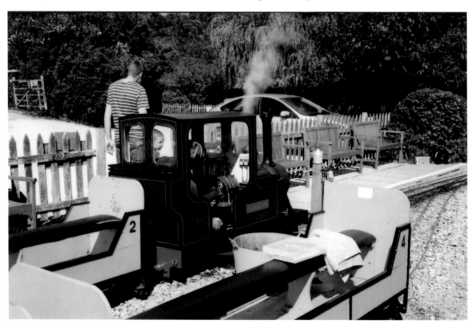

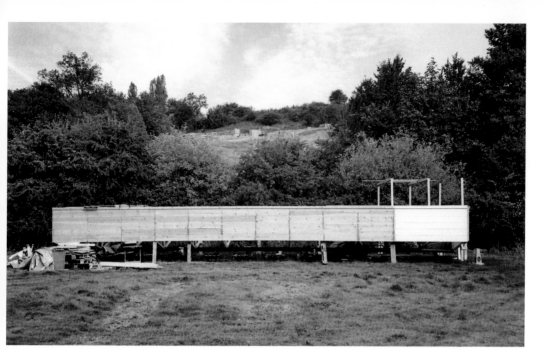

The *Tudor Rose*

In 2009 I had an idea to construct myself a 60 foot long by 12 foot wide canal boat. Eventually I found someone willing to let me use a piece of land to build the hull. That land was part of the miniature railway and in 2010 I started on the hull, seen here April of that year. All through the summer I toiled, much to the delight of those travelling on the miniature railway. With the job near completed I moved on when the new owners agreed to let me stay until Easter 2011 to finish the task.

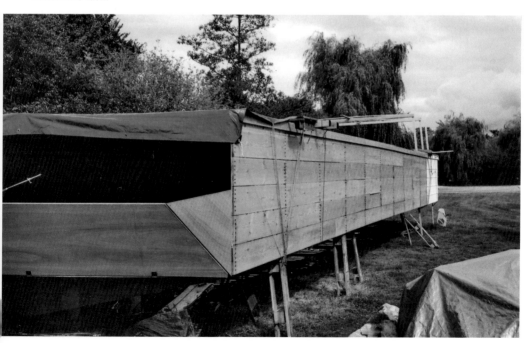

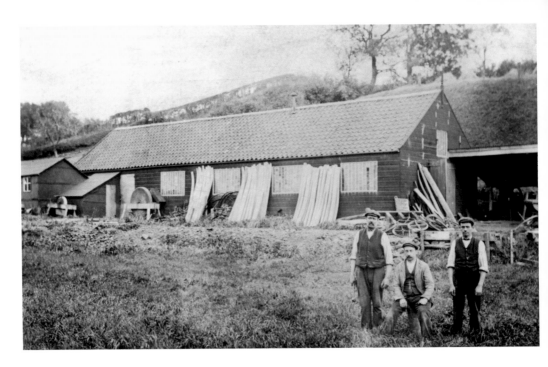

Benson's Agricultural Engineers

Messrs Benson's Agricultural Engineers, established in 1860, stand proud in front of their premises at Ruswarp. Benson was a well-respected craftsman and much sought after to build and repair mill machinery. Interestingly, I have billheads that show he also made coffins. It has hardly changed, only in the last five years have there been a number of successive owners and uses, and it was not many years back when one new owner was replacing the sign over the door, that the original lettering came to light (see next page).

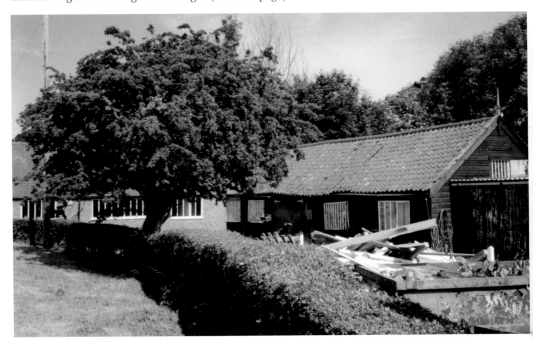

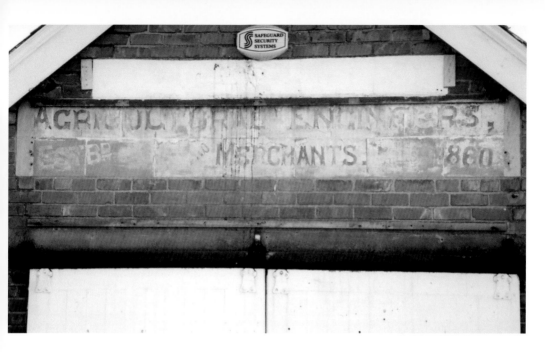

Curious Ruswarp

Two completely different photographs of life in Ruswarp that possibly span a century or more; the upper one shows Benson's painted sign as mentioned on the previous page. The other is passed by countless people but probably never noticed. It forms part of the wall to the churchyard, and is an older section showing marks made by the regular sharpening of a blade. The only instances where I have seen this before, it is usually connected with a church and made by men sharpening arrows, as archery had to be practised by law on Sundays. I wonder?

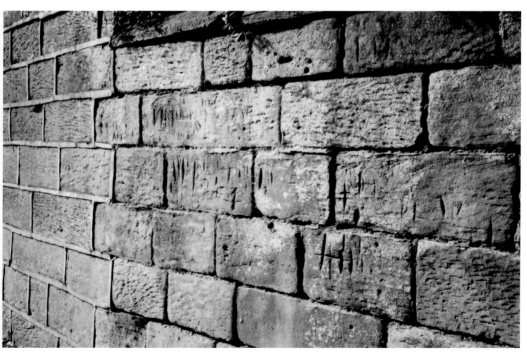

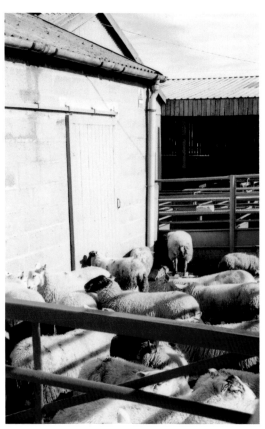

Ruswarp Livestock Market

There has probably been a cattle market here for centuries, Ruswarp being formerly a rural and agricultural-based community. It was likely in association with this that the market sprang up as farmers and their families came to buy and sell. Peddlers would no doubt congregate for the benefit of the farmers' wives and the ladies would trade. When I first knew the mart it was well-attended with auctions and a mixture of animals; however, the most recent 'foot-and-mouth' outbreak reduced many farmers to diversify and attendance at the weekly Wednesday sale has fallen off.

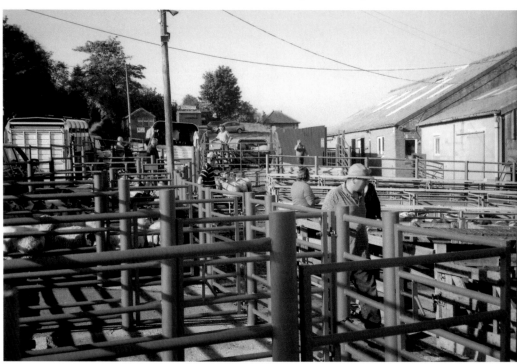

Railway Cottages

On this side of the river – the south bank side – two red-brick houses known as the 'Railway Cottages' stand apart from the livestock mart, the garages, the builders' merchants and other small industrial traders. These were put up in the nineteenth century to house railway workers. Today they have long since been sold off by the railway company into private ownership, and in the garden of one is a delightful collection of vintage cars under different stages of restoration. I was able to get a good photograph of this old Austin saloon car.

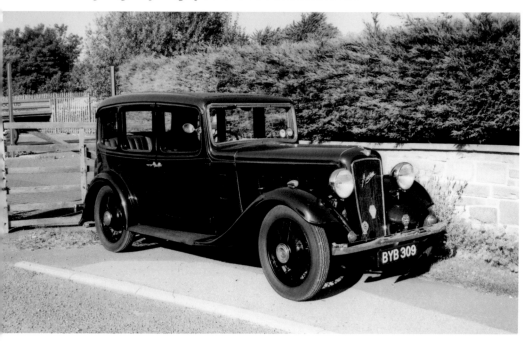

Carr Mount

Along The Carrs between Ruswarp and Sleights can be found a number of grand country mansions whose owners once farmed the land around here. Indeed, within the district of Ruswarp and Sleights there are probably more of these fine gentlemen's residences than in any other suburb of Whitby. A house has been here since 1573 but the present Carr Mount dates only from the mid-eighteenth century and is not on the original site where the remains of the old house stand. Recently, the estate has had a complete makeover and the home farm turned into holiday accommodation.

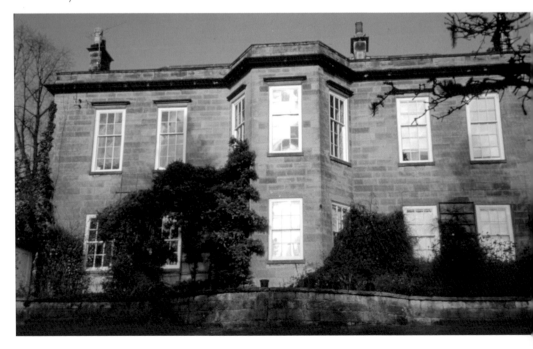

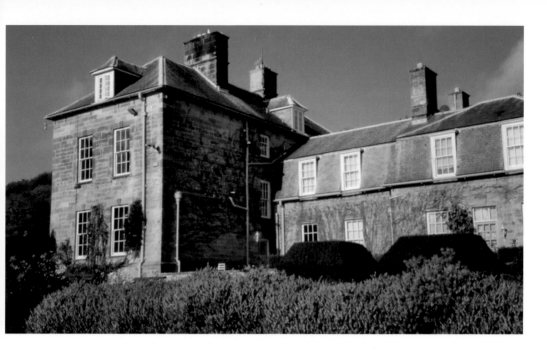

Carr Hall

Carr Hall, the next mansion along the Carrs, is another fine stately home. It is of the same period as Carr Mount, but much larger. It has had a chequered history, but in modern times it is best remembered as a school, opened in 1944 by the Order of Holy Paraclete and staffed by nuns. At that date a good many children who attended the boarding school were evacuees, many from Canada. The nuns, who were based at Sneaton Castle, sold it in 1995. After this it was developed into a small, tasteful gated private estate with apartments and houses.

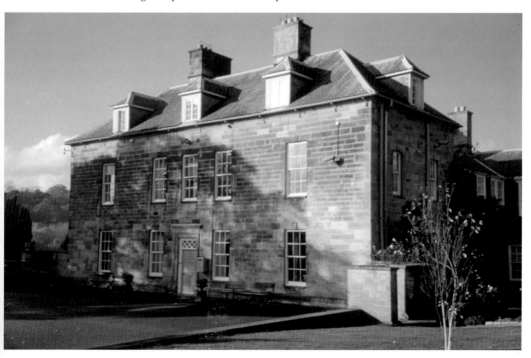

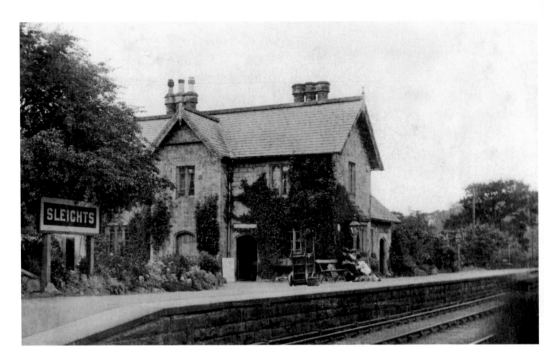

Sleights Railway Station

The next village along the railway is Sleights, although technically the station lies in the hamlet of Briggswath. It has another of Andrew's 'Tudor style' stationhouses, again a private residence. In the bottom photograph the new road bridge of 1937 can be seen. This replaced the 'ancient stone bridge of three arches which crossed the river eighty yards downstream destroyed by flood in July 1930', as recorded on a plaque fixed to the new road bridge that can be seen in the photograph below.

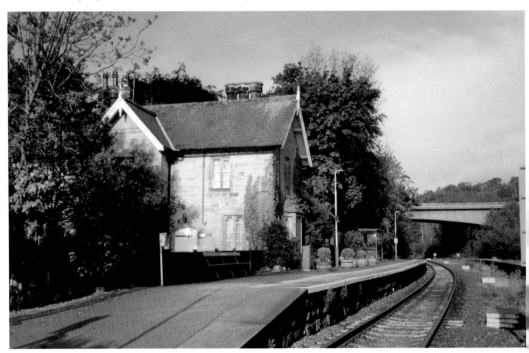

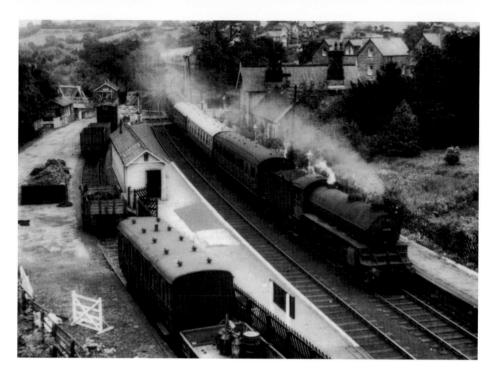

Sleights Railway Goods Yard

Sleights railway station was closed under the Beeching Axe of the 1960s. However, before that it was a busy station with railway sidings and a coal yard. After closure, gradually things began to slide as the station went into decline. The wooden platform waiting room was dismantled and re-erected at Grosmont station. Years later, the railway tracks were lifted, making it only a single-track line from Whitby to Middlesbrough. The final nail in the coffin was when the coal man left to set up elsewhere.

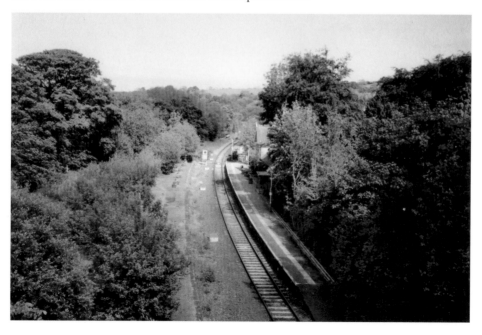

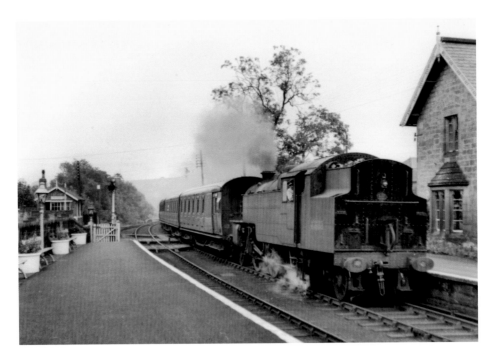

New Ways, New Days

When the Esk Valley railway line was threatened with closure in the 1960s, public pressure prevailed and it received a stay of execution. This rail link is sometimes the only link with the rural villages up the Esk Valley in deep winter when the roads are impassable. Sadly, however, they ran very few trains – only three a day out and three back. In very recent years the North Yorkshire Moors Railway, after helping to strengthen and repair the track, has got permission to run steam engines and diesel locomotives into Whitby town.

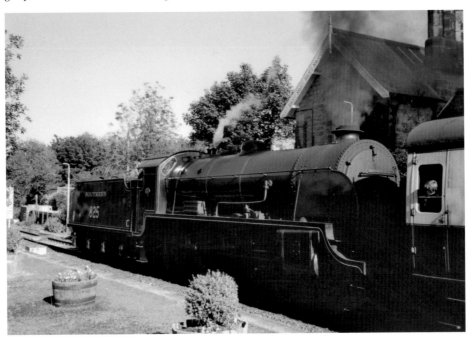

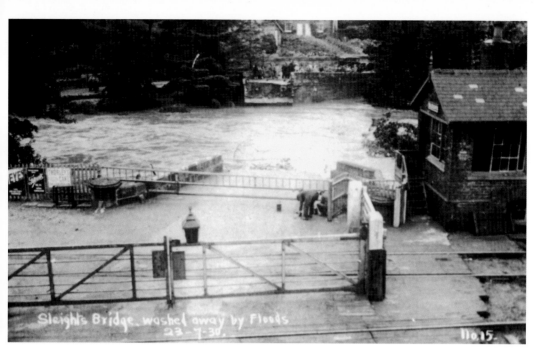

Sleights Bridge. washed away by Floods
23-7-30.
No.15.

The Floods of 1930

During the 1930 floods, the 'ancient stone bridge' was washed away causing a great deal of inconvenience. It was here that the main road from the moors into Whitby crossed beside the station and was guarded by a level-crossing. It also carried the main water and sewage pipes for the village. As a consequence services were severely disrupted. All this was eventually tidied up and now it is hardly possible to tell a level-crossing ever existed here at all. Only the signal box remains from this scene and that stands derelict.

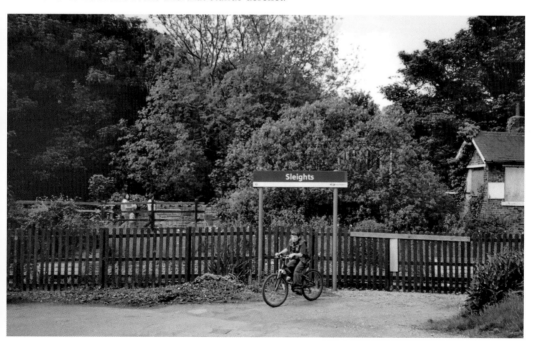

Sleights

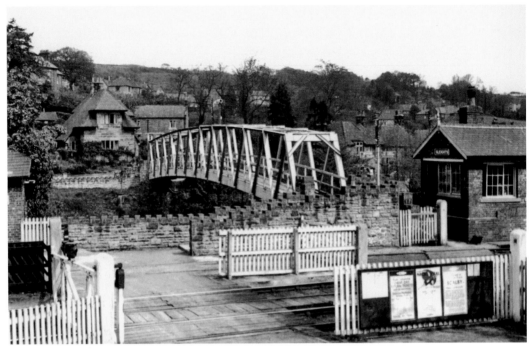

Sleights Level Crossing and Signal Box

From my home on The Carrs, it is only a few minutes' walk to Sleights station over the Esk by way of the footbridge clearly visible before the tree growth. I often walk this way and, on Friday 24 August, I thought to use the train. As usual I followed the footpath beside the disused signal box, and prepared to wait for the train. It was then that I realised what was different about the view across the track – a new information board had sprung beside the gate up where none had stood before.

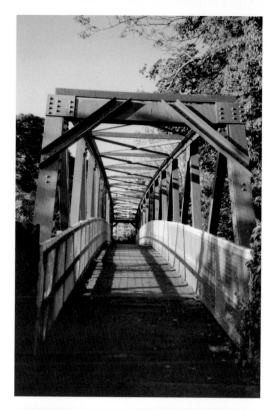

Briggswath Footbridge

Following the floods of July 1930 that swept away the Sleights old road bridge, a new footbridge was quickly put up in the short term to allow access to the other side – a short-term measure that soon became permanent. Opposite the village side, facing you is this beautiful cottage (below), which was erected as the lodge gatehouse to the Woodlands Estate. Woodlands House is almost two miles away – that was the extent of its boundaries. Of course, when first built there was no modern road and the drive of Woodlands came onto The Carrs at this point before turning up Carr Hill Lane as an alternate route to Whitby or to gain the moor road to Guisborough and beyond. The Lodge is one of the many architectural gems of the district. At this point geographically the traveller is in the hamlet of Briggswath, which means 'bridge ford' from the two words 'brigg' – bridge and the Norse word 'wath' meaning crossing or ford, the remains of which, in the form of wooden piles, can still be found in the river bed.

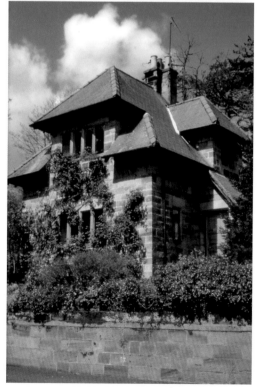

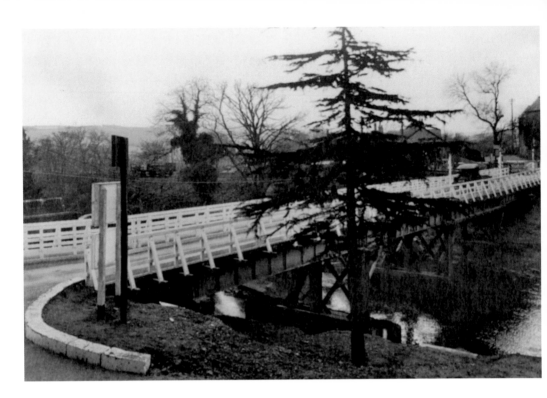

Flood Damage

Above, the temporary road bridge to replace the stone bridge (below), washed away in the floods of 1930. The first permanent bridge here was built between 1190 and 1211. It was also agreed that it should be free 'for ever for the furtherance of trade'. A bridge was destroyed here by flood in 1720 and a temporary bridge was replaced around 1764. The building of that took several years to complete, and led to the death of the contractor through an accident. Sadly, this bridge (below) was the one destroyed by the flood of 1930.

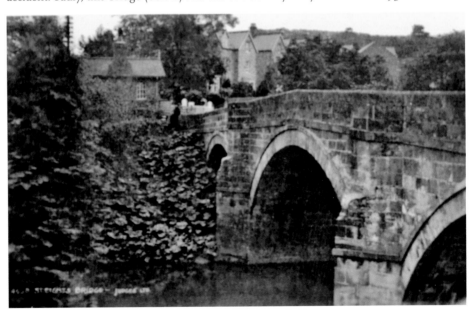

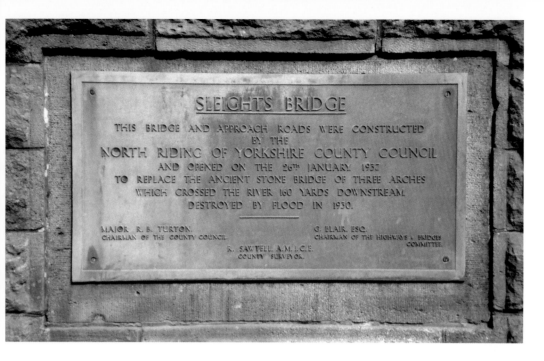

Sleights New Road Bridge

A modern view looking along the new road bridge, which carries a plaque that reads, 'Sleights Bridge. This bridge and approach roads were constructed by the North Riding of Yorkshire County Council and opened on the 26 January 1937 to replace the ancient stone bridge of three arches which crossed the river 160 yards downstream destroyed by flood in 1930'. The road to the left leads along the Carrs to Whitby, and the turn to the right is the entrance to the drive leading to Groves Hall, the Woodlands, and St Oswald's Christian Retreat.

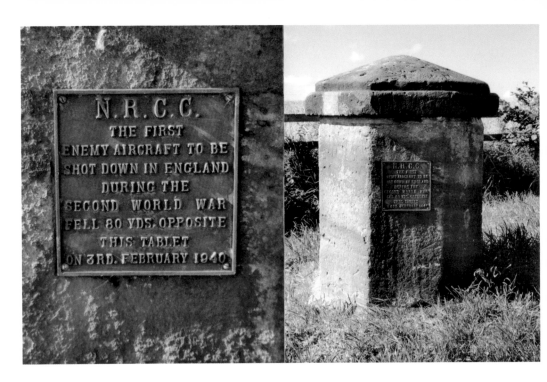

A Second World War Record

When the ancient stone bridge washed away at Briggswath and was replaced in 1937, the old stone posts were scattered around the village. One stands on the roundabout at the crossroads of the A171 Whitby–Guisborough moor road and the A169 Whitby–Pickering road, near to Banial Flatts Farm, which is where the deed inscribed on the plaque occurred. This German aircraft was shot down by Group Captain Peter Townsend, more noted for his long-time affair with HRH Princess Margaret.

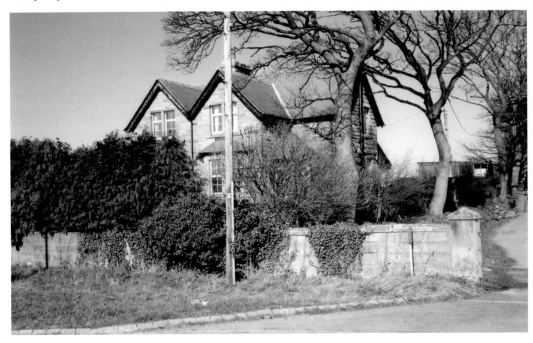

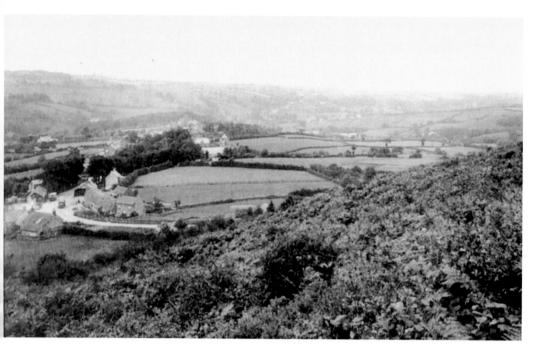

Sleights Bridge Looking Towards Sleights

Above, a view looking uphill toward Sleights, with the newly-opened road bridge of 1937 below. On the very edge of the photograph is the left-hand turn towards Whitby via Briggswath. In this early modern photograph the village is so small it hardly makes any impact on the landscape compared with the aerial photograph below, taken in 2000, showing the main highway on the left looking from the top of Sleights toward the new bridge (top left).

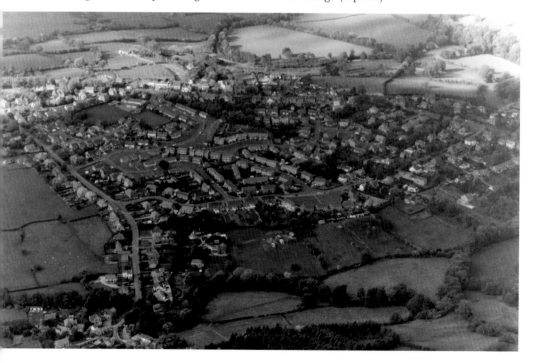

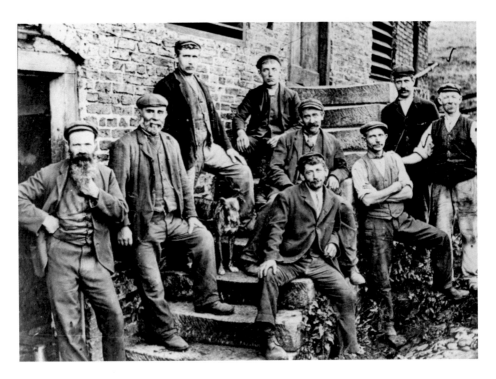

The Woodlands and Local Industry

It was partly the tanners at Aislaby who kept the Walker family in the manner to which they had become accustomed, when they bought and rebuilt the Woodlands here over two centuries ago (below). Of course it was not just the tannery that provided their income. They also had extensive alum works used in the leather industry, shipping to move their goods about, coal mines to provide fuel to power their machines, and, of course, to warm their other residence Haggersgate House in Whitby for the ladies to stay over when they went shopping or dancing.

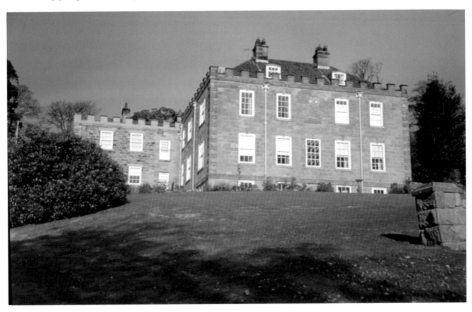

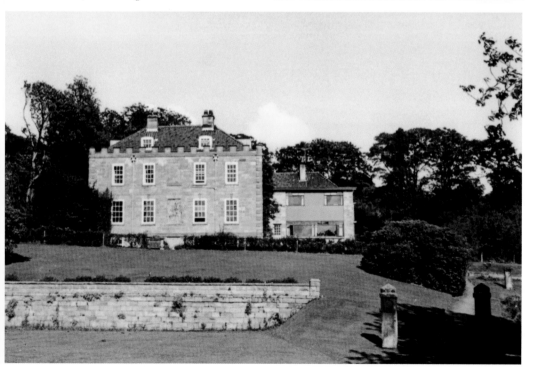

The Woodlands

John Yeoman's wealth from his Eskdaleside Alum Works, founded in 1764, purchased and rebuilt the house, which was originally built in 1470. Later it was further remodelled by his son, the Revd Henry Walker Yeoman, Archdeacon of Cleveland, who succeeded his father in 1782. In time it passed to five nieces who did many good works in the district. In modern times it was a school run by the nuns from Sneaton Castle. Today it has become private apartments. Of interest in the grounds is the eighteenth-century ice house, shown right.

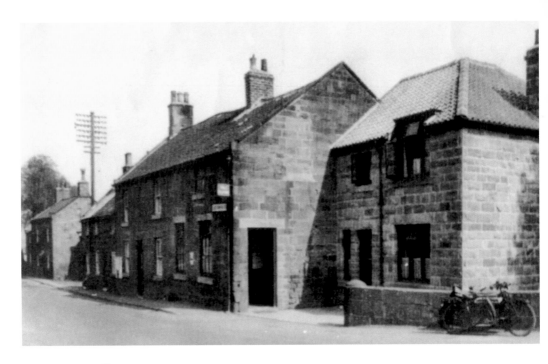

The Old Post Office

Sleights as a place-name possibly comes from our Viking ancestors, whose word for a waterside meadows was *Sletta*, and the name appears today as Sleights, coming down to us through its thirteenth-century form of *Slechetes*, meaning 'the flat ground of the water meadows'. Briggswath was not always a rural idyll. Up to the beginning of the twentieth century there was an ironstone mine and a tannery here, the latter retained in the house name 'Tannery Cottage'. The first building set back was once a sub-post office to the main post office in Sleights.

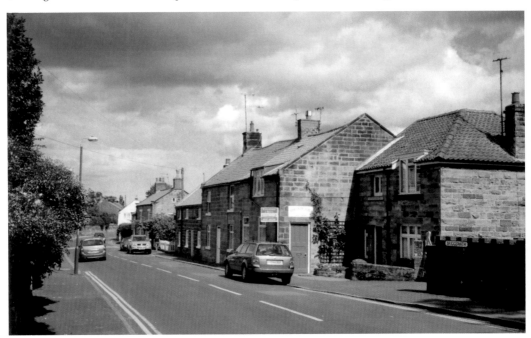

Briggswath Wesleyan Methodist Chapel and Toll House

By 1820, the Wesleyans had erected a small chapel and started a Sunday School at Briggswath. They also owned three adjoining cottages. The whole of this property was held in trust. Later the Trust became a charity. In 1905 the small chapel was replaced at a cost of approximately £1,000. The architect was Mr A. E. Young of Whitby. The toll house, erected in 1764, later became the local village school. During the war it was used by the Home Guard, and since then it has been variously a hairdressers', antiques shop and is now a holiday cottage.

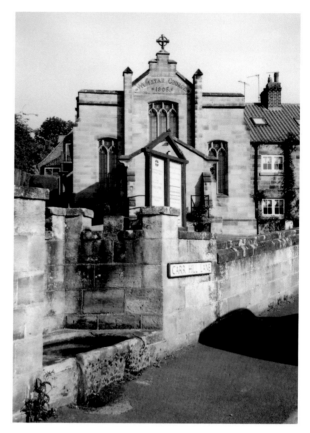

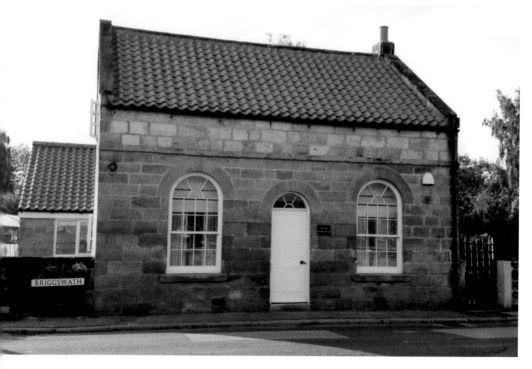

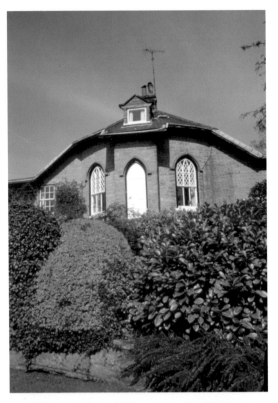

Brook Cottage

In Briggswath, a most interesting property can be found. Brook Cottage was designed and built by Mr Francis Pickernell (*d.* 1871), engineer to the Harbour Authorities, and gave its name to Brook Park, an estate of houses that now surround it. In 1835 he designed the swing bridge, and had previously rebuilt the Whitby Piers, as well as designing and building the lighthouse at the end of the West Pier, below. Known locally as 'Pickernell's Folly', the stone was hauled from the harbour to Briggswath by his remarkably small ponies. A story is told how on one occasion, when the ponies were finding difficulty in getting to the top of Downdinner Hill, a stranger offered to 'burr' or brake the wheels of the wagon while their master led them. The stranger turned out to be the famous railway engineer, George Stephenson. The individuality of this building comes from its interior design, which by a surplus of doorways, allowed a clear 'run' in bad weather through dining room, kitchen, scullery, spare room, two bedrooms and lounge, for the Shetland ponies. Six of the interior doors were blocked up in 1939 by previous owner Mr Walmgate, a former postmaster at Sleights.

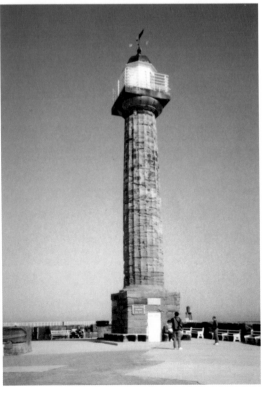

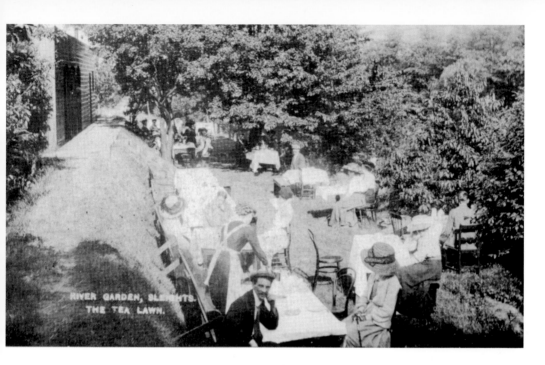

River Gardens Tea Rooms, Sleights

Like Ruswarp at the other end of The Carrs, the river was a big attraction. The Edwardian tea gardens still ply their trade in cream teas, enlarged today by the addition of a garden centre. There is still the putting green, but sadly, the rowing boats have gone on the grounds of health and safety. This area was first populated in prehistoric times and the remains of Bronze Age man has been found here on this site. The soil hereabouts was also trodden on by Cavalier soldiers.

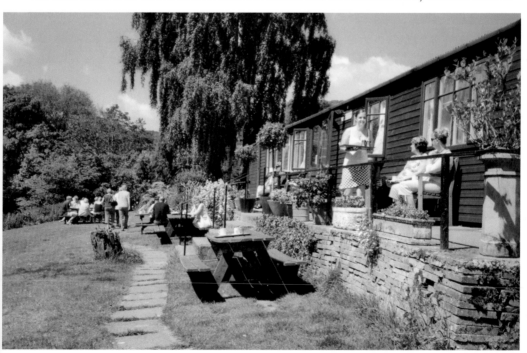

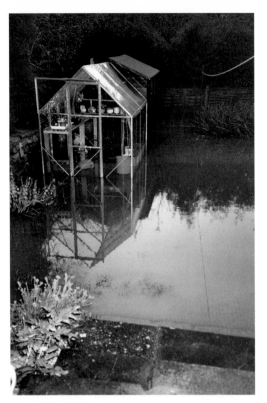

Home, Sweet Home!

This shows the flooding of the River Esk behind my home on The Carrs in the January of 2000 – not a very auspicious start to the twenty-first century. Our property backs onto the Tea Gardens, whose business was adversely affected for a period. Luckily our house is built on a sloping site, and while the back garden is on a lower level, the property is six feet above the flood plain. This photograph was taken when the waters were receding and it was only four feet deep. Sadly, one casualty of the flooding was our goldfish. As the waters swept over the garden pond, just off camera to the left, the fish escaped. Call me an adrenaline junkie, but when the flood was at its height, and we watched from the back bedroom, I was amazed and exhilarated at the number of mature trees that sailed by at speed. In another flood in 2003, a couple of trees smashed into the wood-panelled back fence and broke it down – not so happy then; but then I thought, why do we pay insurance, so as not to make a drama out of a crisis? Afterwards, one phone call and soon we had a new, stronger fence.

Grove Hall and Salmon Leap

Before climbing up the hill from the high-rise road bridge, it is possible to see the Esk at close quarters. The River Esk is the longest Salmon River on the eastern side of England and a salmon leap has been here since the Middle Ages to assist the fish as they swim upriver to spawn. Grove Hall has its origins in the medieval period when the monks of Whitby had a watermill here and the building, though eighteenth-century, is all that is left of the mill, which ceased operating in the 1920s.

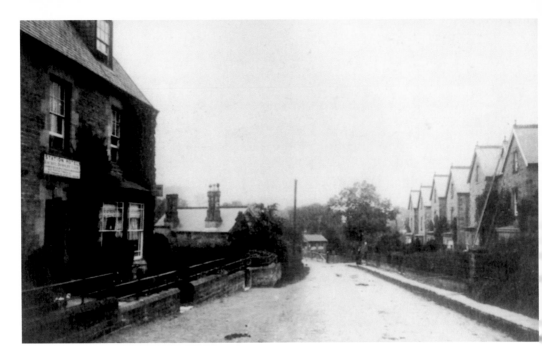

The Station Hotel, Sleights

Coach Road gave access to the railway station at the very bottom and was also the main vehicular highway before 1930. Now it is almost a rural country lane. However, the houses on the right are the same, as indeed is the public house to the left. Today the hostelry has changed its name from the Station Hotel to the Salmon Leap Hotel. The new name reflects its proximity to the salmon leap on the River Esk. The stationhouse with its many tall chimneys is now obscured by mature trees.

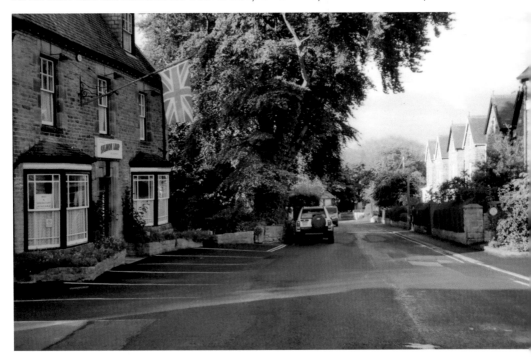

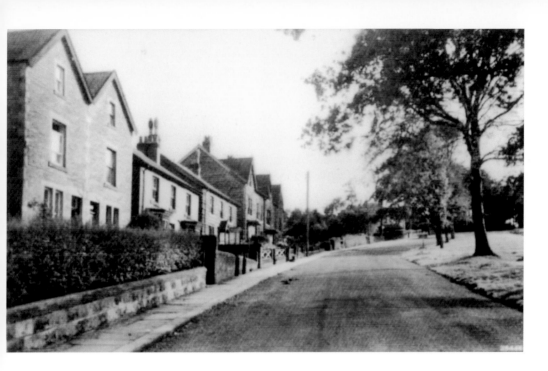

Coach Road

Coach Road was once the main highway, with these houses standing on the side of it. However, with the opening of the new bridge and road in 1937, a slight diversion of the line left these houses isolated and quieter. Most of these Victorian villas date from 1870 to 1899, making them just over 100 years old. Coach Road got its name from the eighteenth century when it was a turnpike road with stagecoaches and private coaches racing up here on the way to Pickering and beyond, much as modern traffic does today.

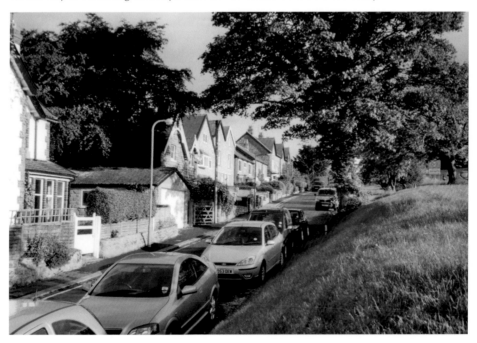

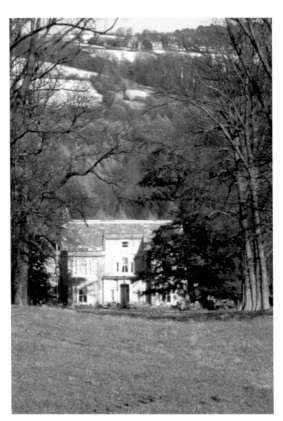

Esk Hall, Sleights

This is on the site of the 'manor called Eshdalehalle' mentioned in the sixteenth century. A house called Eskdale Hall is recorded as the property of Whitby Abbey as early as 1540, but the present building only dates from the eighteenth century. It once had two wings. The handsome avenue of trees that once stood either side of the drive was shut up due to a commonly held belief that whenever the avenue is thrown open for traffic a death will occur. In 1871, Mr Gladstone, the Prime Minister, planted a tree on his visit there.

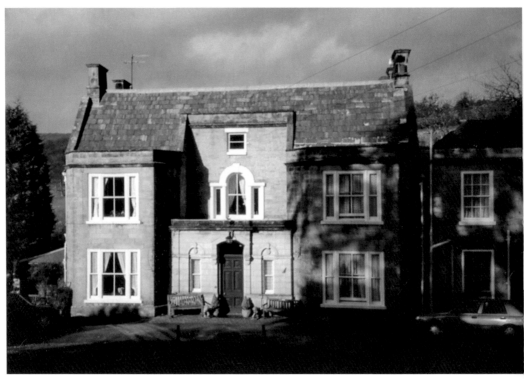

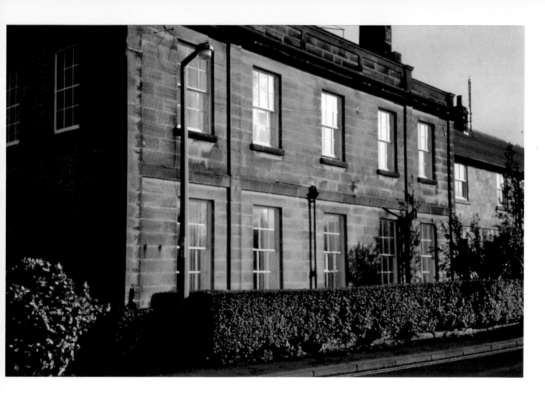

Carr View, Sleights

Carr View was built shortly after 1819, but by the second quarter of the nineteenth century the accommodation had proved insufficient and a single-storey service wing was added (since raised to two storeys) in a different style. After a number of owners, a local directory dated 1937 lists Carr View as a boarding house owned by one Mary Marsay. In recent years it was a care home and has now become apartments. Next to the hall stands the single-storey stable block erected in 1882 (below), which is today a residence and café.

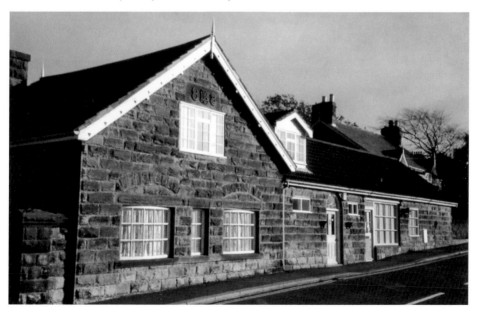

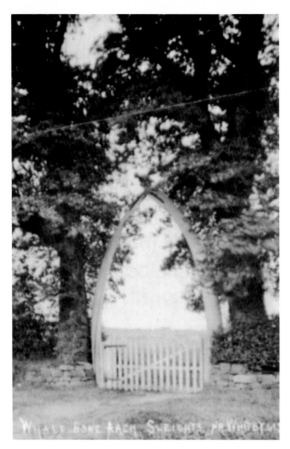

The Whalebone Arch and Botham's

No longer in existence today, the whalebones dating from between the two World Wars graced the entrance to a field until 1970, when it became the village car park. Almost immediately opposite the car park is a branch of Botham's, the famous Whitby baker's. Elizabeth Botham began her business as a widow in 1869 selling from a pie cart. Later she set up in Skinner Street, where the company's main shop and restaurant is. She also ran a beer house called 'The Hole in the Wall' in 1890, which by 1903 she had given up.

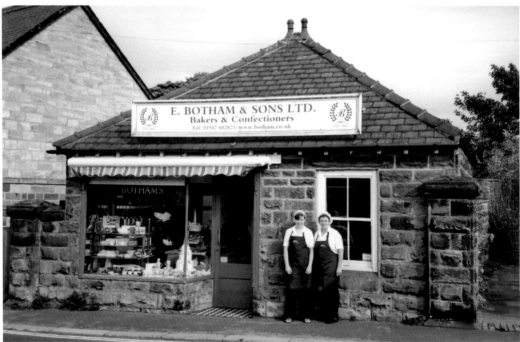

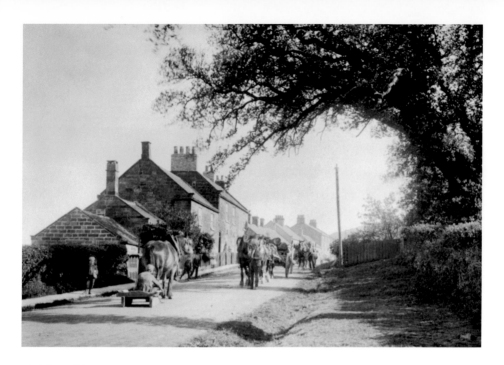

Sleights Village Centre

The chap sitting on a local type of sledge, which was used to haul stone from the quarries around here, would be taking his life in his hands with today's traffic! The butcher's and local village store occupy these old buildings today, just as they did a century ago. These are the same properties, the only difference being the insertion of dormer windows in the roofs – a modern phenomenon. The stone was taken down to the railway then shipped off to the port of Whitby for transportation around the world.

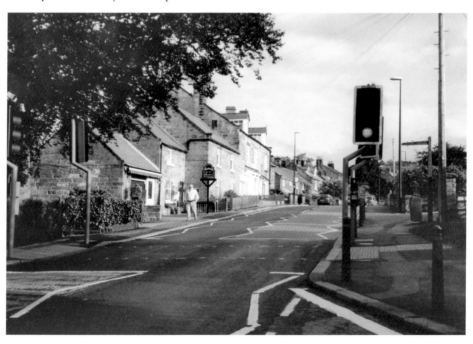

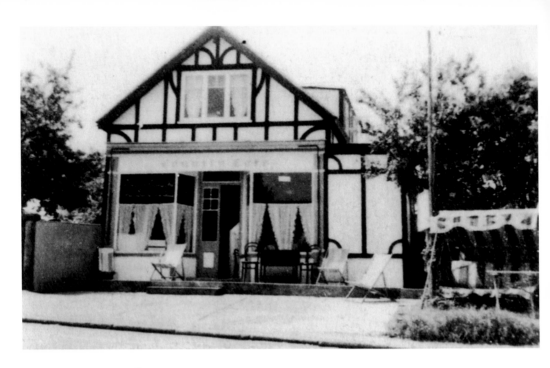

Sleights Post Office

In the previous photographs, to the right of the trees opposite the first cottage is the village post office, a building erected in the 1930s as a country café. Again, there is little change except of use. Today, however, I would not advocate sun bathing in the gaily striped deck chairs, as this is now an extremely busy road and the noise and petrol fumes would soon force you inside. For a number of years the post office was run by a family named Sergeant, but today the postmaster is John Coulson assisted by his son Richard.

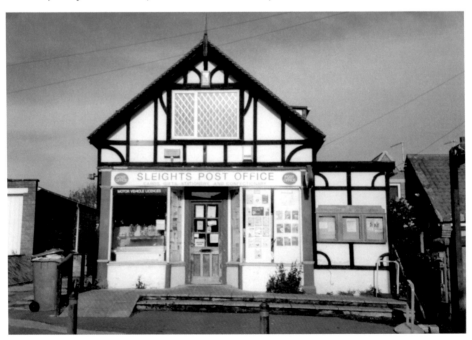

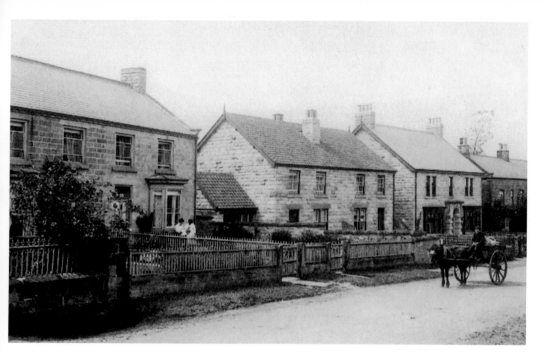

Coach Road

Prosperous Victorian and Edwardian villas line Coach Road at this point just above the village shops of the previous photographs. These are now screened by mature trees that have grown up and which were probably first planted as saplings when these properties were newly-built. The pony and trap appears to be a delivery lad making his rounds, possibly delivering groceries from the local store. However, it is known that the local doctor, also made his rounds by pony and trap.

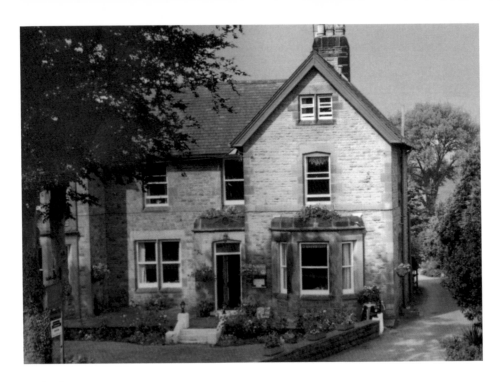

Netherby House

Netherby House was previously known as Primrose Cottage, and today is a pleasant restaurant and country hotel. For many years it was the home and surgery of Doctor Thomas H. English. Well-known in the district, when he first started his rounds transport was by pony and trap – then came the motor car, which he embraced. A noted antiquarian, the family can trace five generations of doctors. His daughter Dr Brenda H. English was a reasonably well-known author of romantic books with Whitby settings.

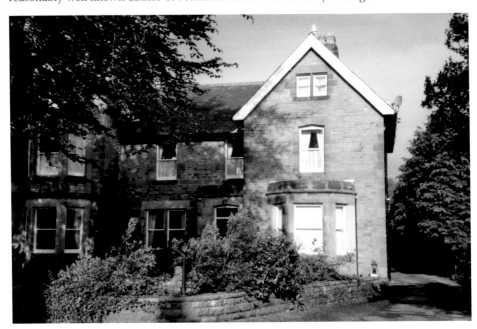

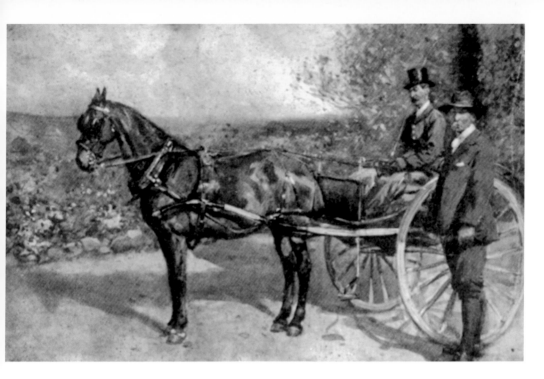

The English Family and Sleights Village Hall

Above, we see Dr English standing with his groom and gig, from a painting. He is wearing his usual apparel: a knickerbocker suit and wide-brimmed hat. Thomas Harks English was born on 9 May 1865 at Aislaby, the ninth son of Dr Arthur W. English and Mary O. Mills. His early childhood was spent at Aislaby Lodge, and in 1884 he went to London to train as a doctor – one of five generations of medical men. He married Anna Riddal in 1893 and began to practise as a GP, first in Hull and later returning to Sleights.

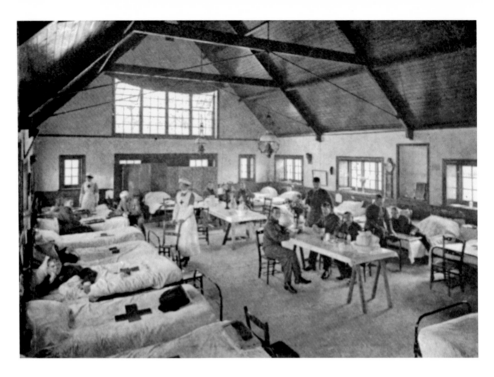

War Work at Sleights

At the outbreak of the First World War, the Village Institute building erected in 1910 at a cost of £650 stood empty and was turned into a Cottage Hospital largely due to the efforts of Miss S. B. Yeoman of the Woodlands. It was organised and run by Dr English and his wife. On 26 November 1914, the first contingent of nineteen wounded soldiers arrived from York. Later, when these moved on, a large number of Belgian soldiers were nursed at Sleights and the photograph shows Miss Yeoman and sisters stood near the back centre wearing hats.

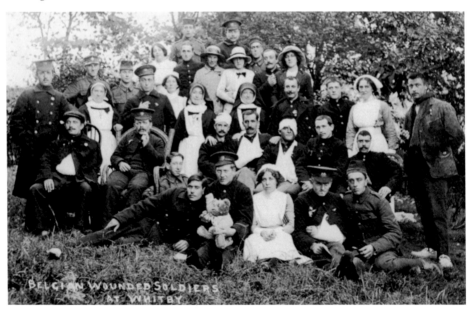

Flint Jack – Edward Simpson

Sleights was the birthplace of Edward Simpson in 1815, later known as 'Flint Jack'. He was born in a small cottage opposite the village pump, below. Aged fourteen, he went as apprentice to the Whitby historian Revd George Young, and became fascinated by geology and antiquities. Leaving Dr Young, he was induced to copy a flint arrowhead by a dealer at Malton. From this he became nationally famous for the skilful 'knapped' flint arrowheads and stone implements, which he sold to museums, academic institutions and numerous people. Always on the move, he perfected the art of forging prehistoric and ancient Roman pottery, and travelled the length and breadth of England, quickly moving on before being discovered. In 1846, a fatal change came over Jack's life when he took to drink. As his fortunes began to ebb and flow, in 1862 for some unknown reason he confessed to his counterfeiting. Once his secret was out there was little chance of selling his 'finds' and while he gave a number of demonstrations to academic societies in London, he was finally reduced to begging. Ironically, it was stealing a barometer and clock when he was fifty-three that put him in prison and he died shortly after.

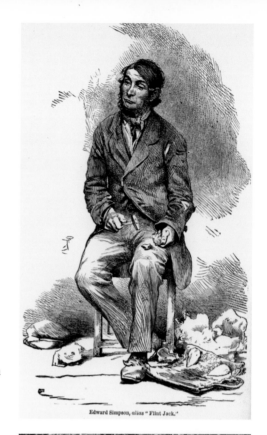

Edward Simpson, *alias* " Flint Jack."

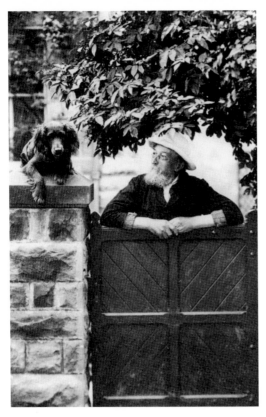

George Wallis, Photographer

Here we see a photographic study of George Wallis by the equally famous Lythe photographer Tom Watson in his garden at Sleights with his faithful dog. Not much is known about this photographer and he did not reach the eminence of Frank Meadow Sutcliffe or indeed Tom Watson. All that is known is that around 1880 he took over the studio of John Stonehouse at Khyber House, now named Streonshalh, at the top of the steep Khyber Pass in Whitby. There is an illustrated nineteenth-century advertisement in a local town directory showing the building with a large sign painted on the gable end. From the photograph it is not possible to identify where he resided, and local directories appear not to mention him at Sleights. Few of Wallis's photographs seem to have survived and he produced few postcards of the locality.

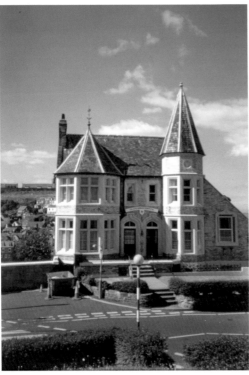

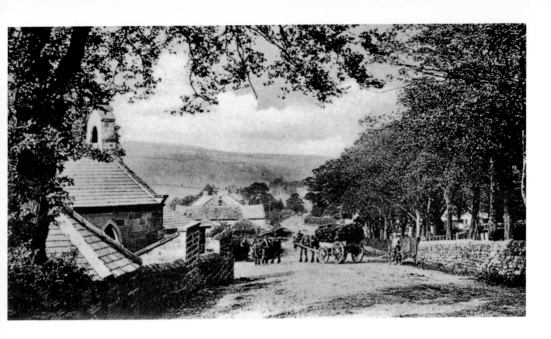

The Old School – Inkwells

Near the top of Coach Road, looking downhill; this highway was the first stagecoach road out of Whitby in 1794, and was a turnpike toll road. On the right is the churchyard wall to the church of St John at Sleights. On the left is the early schoolhouse of the village, now a B&B known as 'Inkwells'. This is almost a crossroads – the horse and cart has probably come up Iburndale Lane and appears to be crossing onto Eskdaleside leading to Grosmont and Goathland.

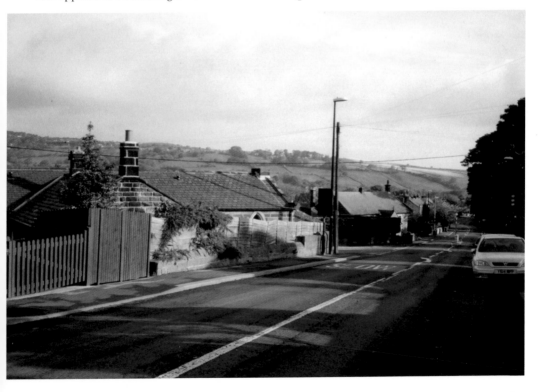

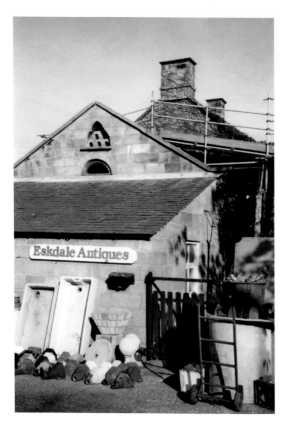

Church House and Eskdale Antiques
Church House, which stands almost opposite the church near the top of Coach Road, carries the date 1908, and has a stone that records that the 'cornerstone was laid by Miss S. B. Yeoman, of Woodlands' on 8 December 1908. For some years it was used as a schoolroom where not only the Sunday School met but the Day School also. Today it still functions as a meeting room and retains its external clock, which 'was presented by Mr H. M. Hutchinson and was dedicated on Whitsunday 1913'. The bell was given as a memorial.

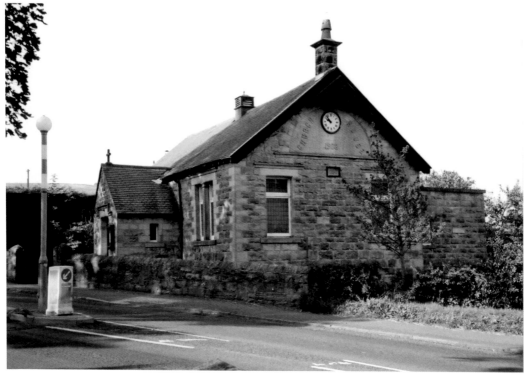

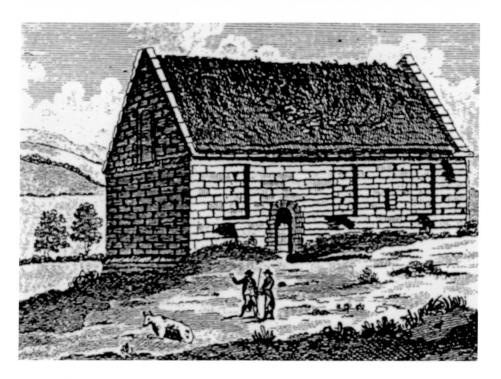

Eskdale Chapel, the Church of Sleights

The ancient chapel on Eskdaleside is shown above around 1774, when it had not long closed. Its origins lay in the thirteenth century. Locally known as 'The Hermitage', it is connected with the ancient Whitby custom of the 'Penny Hedge Ceremony', and the 'Legend of the Hermit of Eskdale'. This remote chapel was the main place of worship for Sleights and surrounding hamlets until the eighteenth century. Today, its remains are a Grade II listed monument in the care of English Heritage and stand near to the railway though hidden in the trees.

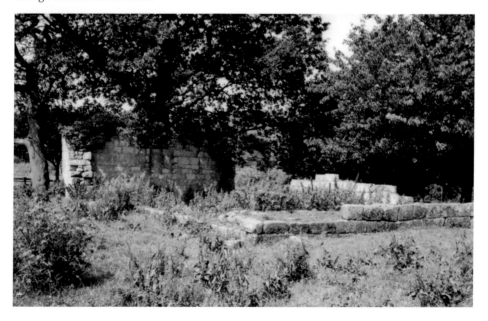

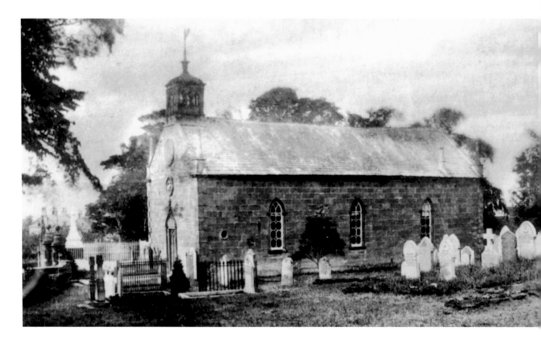

The Old Church at Sleights

This is the old Georgian church of St John, which was put up in the mid-eighteenth century when the older chapel on Eskdaleside was closed and a more central site chosen. It was replaced in turn by a Victorian church, which opened on 20 September 1895 at a cost of almost £5,000. The parish is more correctly known as Ugglebarnby-cum-Eskdaleside and served a number of surrounding hamlets – Iburndale, Littlebeck, Ugglebarnby and farms along Eskdaleside.

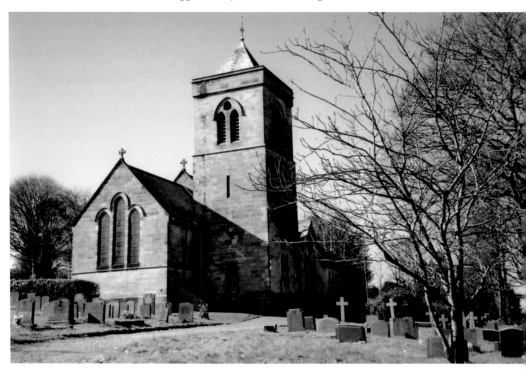

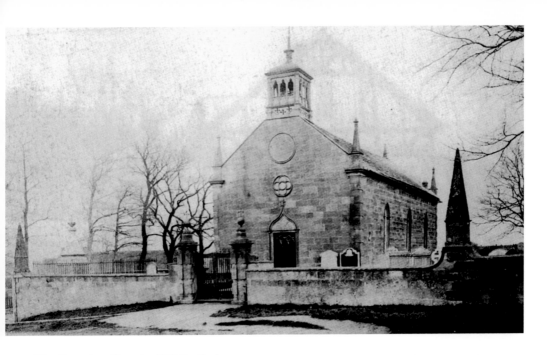

The Georgian Church of St Bartholomew

Sadly, these Georgian churches were often destroyed by the Victorians in the name of restoration on the introduction of the Gothic Revival of the period, although the church of St Nicholas above Robin Hood's Bay managed to survive beautification. The replacement church at Sleights, placed further back from the road, is photographed below by Tom Watson when new in 1895. Few changes to the Early English style have occurred and it remains today very much as it was. The triple lancet windows suggest an echo of the gables of Whitby Abbey.

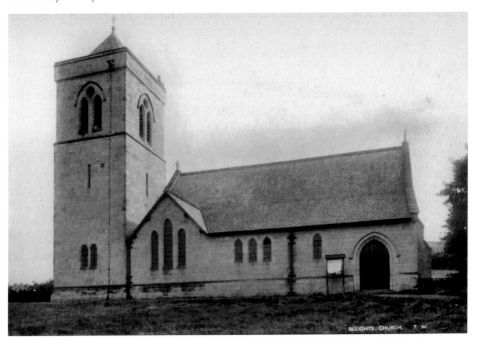

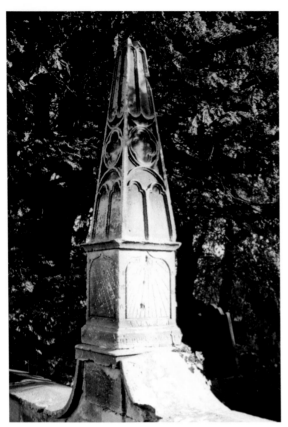

Ecclesiastic Old and New

A legacy of the old Georgian church is this sundial dating from the eighteenth century, which is now set on the churchyard wall. Across the way is the Catholic church of the English Martyrs. The new building was dedicated on Sunday 25 October 1998, and cost around £250,000. This stylish church replaced a dilapidated wood building that stood on the site, and took only four months to complete from the day the foundation stone was laid. The Bishop of Middlesbrough, the Rt. Reverend John Crowley, presided at the official opening service and gave a mass of dedication and consecration.

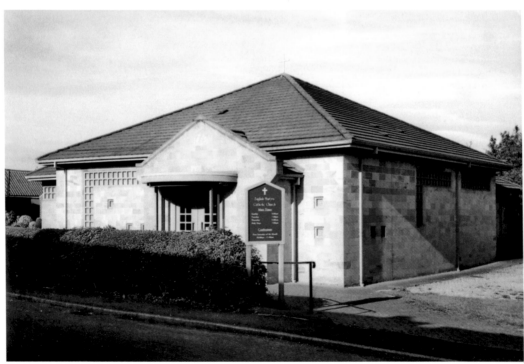

The Old Vicarage and Inkwells

Erected in 1765 by Robert Bower for the curate of Sleights at a cost of £650, the Old Vicarage below is considered an outstanding example of an eighteenth-century rectory. Originally the house was U-shaped in plan, formed of a main range to the front and two lower wings at the rear. In 1791, the Revd Joseph Robertson made significant alterations at his own expense and the two rear wings were enclosed to provide a scullery and water closet. Associated with the Old Vicarage is the ghost of a servant girl who committed suicide here.

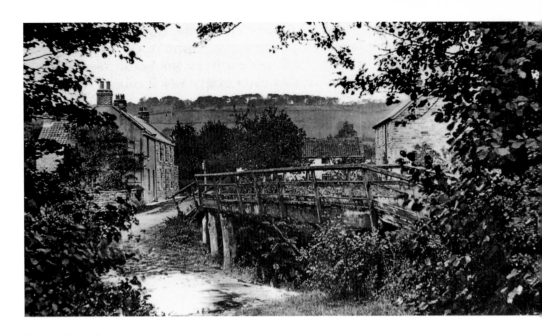

Iburndale Beck

In July 1756, the Surveyor of the Highways in Ugglebarnby was advised to rebuild the bridge over Iburndale Beck (above). A rate of sixpence in the pound was levied on the inhabitants of the parish to pay for it. In 1897, this bridge was rebuilt, and following its completion in early January 1899 (below), 'a very large number of workmen who had been engaged in the construction of the new bridge at Iburndale, sat down to a sumptuous knife-and-fork tea at the Station Hotel, Sleights, to wet the keystone laying and to commemorate the practical completion of the work'.

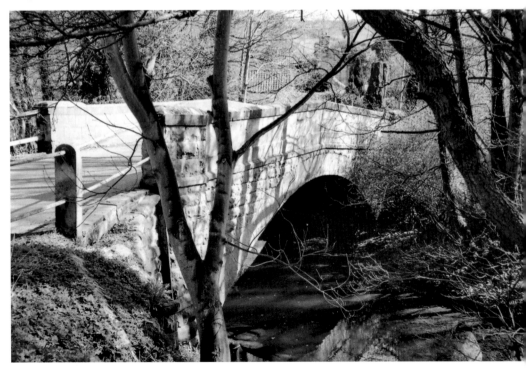

Ugglebarnby Village

Ugglebarnby today is a very quiet hamlet adjoining Sleights and up to the middle of the nineteenth century formed the parish of Ugglebarnby-cum-Eskdaleside. It is reached via Iburndale Lane, passing over Iburndale Bridge before climbing up toward the moors. At one period there existed along much of the length of Iburndale Lane the stone setts or flags of a monk's trod, a form of ancient medieval highway. Surviving at Ugglebarnby is the old Moot Stone from the days of their own parliament, and for centuries it held an important annual Horse Fair.

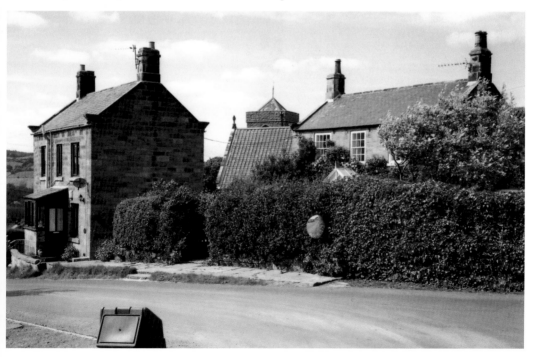

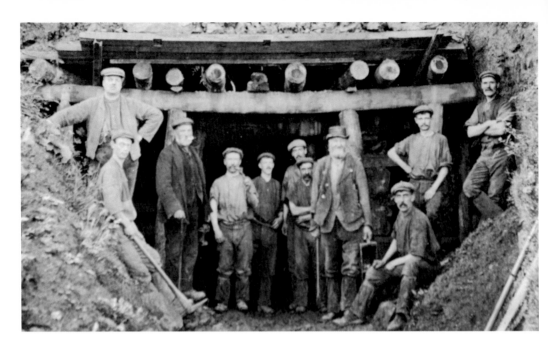

The Doss House and Industry

During the nineteenth century, a considerable amount of mining for coal, alum ore and ironstone took place in the district. As a consequence, a 'Doss House' was erected at Ugglebarnby. A rare survival from the days before poor-law relief and old age pensions, it provided a night-shelter for the elderly and destitute. It was also a lodging-house for itinerant miners and labourers who were given work at 4d a day with their 'grub', by employers in the parish, and had the privilege of sleeping there for their lodgings. Above is the entrance to a typical nineteenth-century mine.

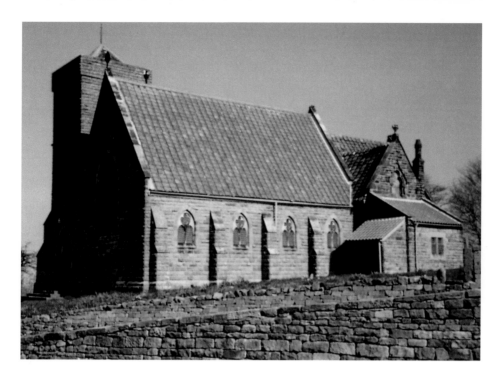

All Saints Church, Ugglebarnby

The church here can trace its origins to at least 1137 when it was a chapel of Whitby Abbey, and early stones can be found in the fabric of the present building. The first church was probably rebuilt around 1700. In turn, the eighteenth-century plain chapel was pulled down and replaced with a 'modern' church in 1872. It was designed by the Diocesan Architect Noel Armfield, of Whitby, and is in the Early English style of architecture. Inside, surprisingly, it is quite sumptuous with good carving in the chancel; it was refurbished in 1866.

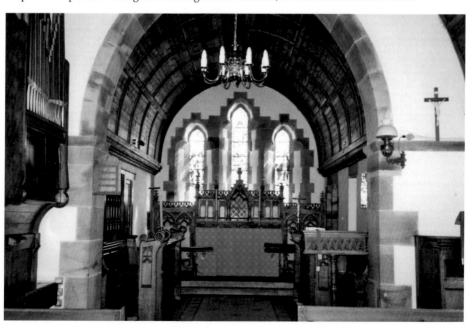

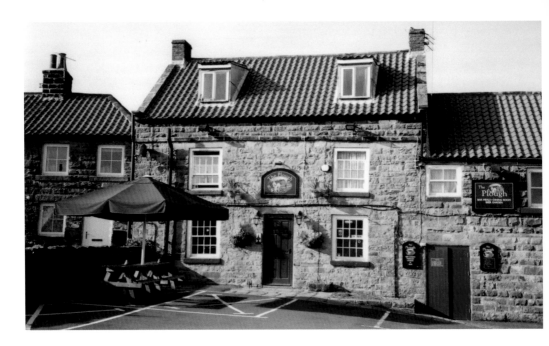

The Plough Inn and Sleights Hall

The Plough is one of the oldest institutions in the village and once supported a quoits team. Quoits is an ancient game of skill where teams tossed horseshoes (now round metal rings) with the aim of landing them on a peg on the ground some distance away. Sleights Hall, rebuilt in 1762, is often described as the 'Old Hall'. In 1893 it was much enlarged, with a third storey added. It became a Repton School until around 1937 when it was again a private residence. The old school bell still hangs on the north wall.

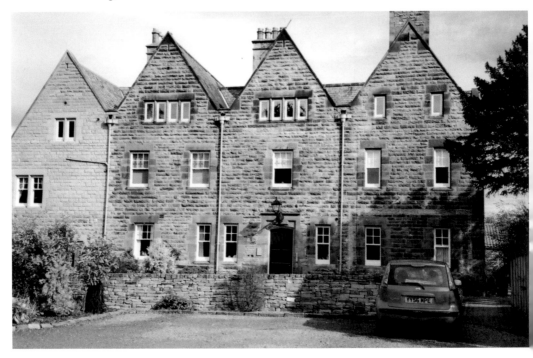

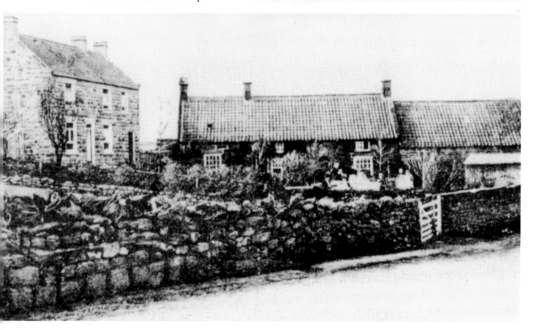

The Notorious Blue Bank

Above is the scene of a fatal accident on Blue Bank, Sleights, when a charabanc failed to negotiate the steep hill on 22 July 1929 and crashed into a farmstead. Four passengers were killed and a further eight were seriously hurt. The date fell on a Sunday, and the family of the farm were all seated round the dinner table having a roast beef lunch. From the early 1900s, visitors could be conveyed by the local butcher in his pony and trap from the railway station at Sleights to admire the fine view from Blue Bank top.

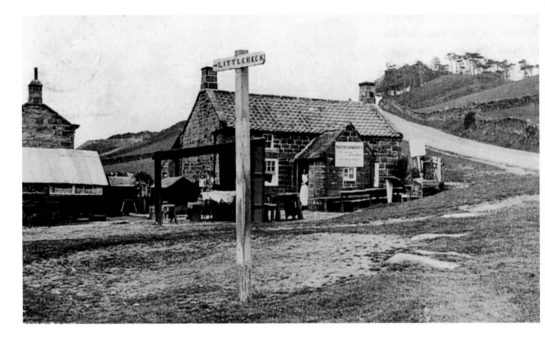

Blue Bank Tea Rooms

The notorious Blue Bank, which enters Sleights from the south along the A169. Off to the right is Littlebeck. The sign on the wall of Blue Bank Tea Rooms states, 'Refreshments, Tea, New Milk and Mineral Waters, Turf Cake a Speciality'. One owner, Mr and Mrs J. J. Foster spoke of the numerous sixpenny pieces that had been found in the garden, which had rolled off the tables – the charge at one period for the teas.

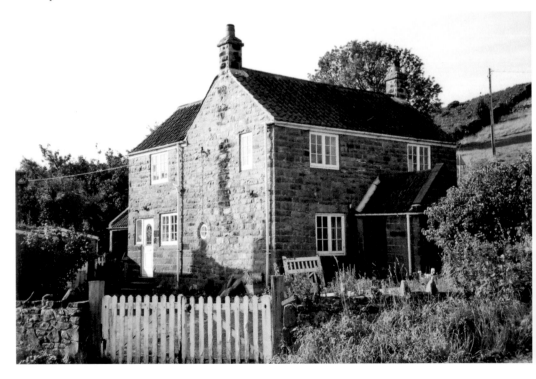

Sleights Beacon and the Millennium Celebrations

Sleights has always had its own beacon, marked on the Enclosure Map of 1760. The site was described as on 'the edge of the moor some 80 chains south-west of a bench mark on the churchyard corner and south of the disused quarry above Partridge Nest Farm on Eskdaleside'. In times of trouble, beacons were a means of spreading the word and many places retain a 'Beacon Hill' as a place-name, such as at Pickering below. For the millennium celebrations, the local parish council erected a new beacon, seen above with Councillor Eric Preston and village residents.

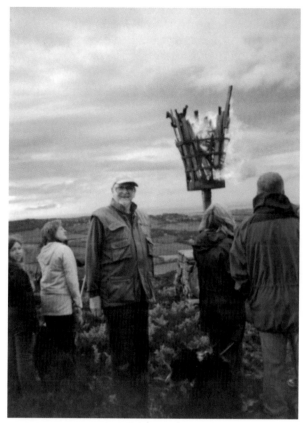

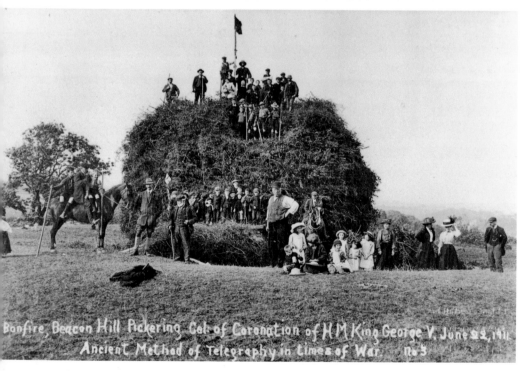

Bonfire, Beacon Hill Pickering. Cel. of Coronation of H.M. King George V. June 22, 1911. Ancient Method of Telegraphy in times of War.

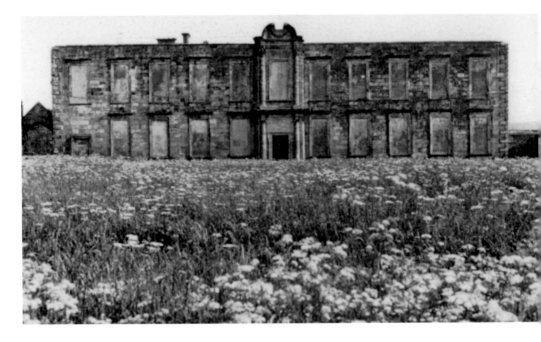

Abbey House

For centuries, Sleights and district was under the ownership of Whitby Abbey and then the Cholmley family of Abbey House. The north wing of Abbey House lost its roof in 1790, from which time it was abandoned. At one time a hotel, in 2001 a new visitor centre for English Heritage was created inside the empty shell. Windows were carefully opened up and a glass 'greenhouse' was erected. Excavation under the grassed area revealed the original Elizabethan pebble-patterned courtyard, which was restored and left on view. In 2009 a replica of a gladiator was set up as the focus.

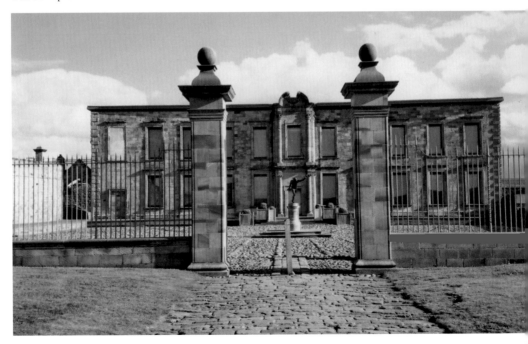